The Secret Science Behind
Movie Stunts & Special Effects

This book is dedicated to my wife Maegan, who has patiently raised our family while I work; to my three boys, Clayton, Paxton and Dashton, who have inspired me to organize what I've learned so that it can serve the next generation; and to my mother and father, who, by example, encouraged my passion for exploration and discovery.

The Secret Science Behind
Movie Stunts &
Special Effects

Steve Wolf

Skyhorse Publishing

10 9 8 7 6 5 4 3 2 1

Library of Congress Cataloging-in-Publication Data

Wolf, Steve.
 The secret science behind movie stunts & special effects / Steve Wolf.
 p. cm.
 Includes index.
 ISBN-13: 978-1-60239-040-9 (hardback : alk. paper)
 ISBN-10: 1-60239-040-1 (hardback : alk. paper)
 1. Cinematography--Special effects. 2. Stunt performers. I. Title.

TR858.W65 2007
778.5'345--dc22
2007004649

Printed in the United States of America

CONTENTS

Stunt man Spike Silver rehearses a stunt for *Crocodile Dundee II.*

Cheryl Duncan offers one key to success:
Keep hanging in there.

Cheryl Duncan shows what happens when you combine gravity, bravery, science, and safety.

INTRODUCTION

When I was in first grade, my neighbor Ally Sheedy knew one thing for sure about me; I loved science. On my fifth birthday she got me a big battery and a spool of wire. I used them to make a reading light for my bunk bed, and an alarm system to detect when my little brother tried to play with my toys. I had a book about electricity that showed me how to do it.

I was eager to learn about science, and remember being excited when my teachers told me it was science time... but it turned out that I hated science in school. My teachers seemed focused on measuring, charting, graph-

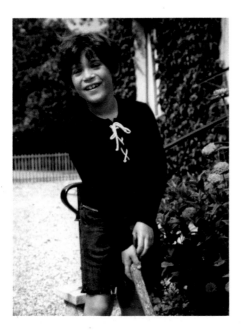

ing, writing things up, making everything neat, tidy and organized. According to them, science was the art of organizing reports. I wasn't good at that kind of thing, so I thought I must not really like science after all.

Still, at home, I would build cable cars, take household items apart to see how they worked, (including my mom's piano) and do experiments—especially those involving rigging and fire. I liked hanging in harnesses, and by eight I was more comfortable on the outside of my

house than on the inside. I built
a spiderweb of ropes that let me
climb all over my house.

Of course, burning little cars and
crashing toy trains followed.

So, while I was no scientist accord-
ing to my teachers, I was building a
great love of how things worked—on my
own. I didn't know it, but I was independently
becoming a scientist.

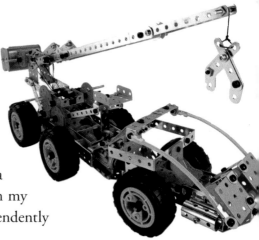

Through Lego's, model rockets, hot air balloons, Erector
sets, Tinker Toys and other mechanical toys, I was exploring and falling
in love with the engineering, physics and chemistry that make the world
work. Levers and pulleys, electric circuits, ropes and harnesses, and chem-
istry sets were my favorite play toys. While my classmates were becoming

great science board display presenters, I was pursuing what would remain my life long passion—learning about the world and how it works, and using that knowledge to do things I thought were cool and exciting. I was following my dad's advice of finding what I loved to do, and figuring out how to make a living at it.

For 20 years I've used my love of "tinkering" to create movie stunts and special effects... figuring out how to translate words on paper into physical events that can be filmed for movies, and doing it safely.

Along the way, I've discovered something I love even more than figuring out how to zipline from building to building or

These pictures were taken on the set of Disney's *Jungle Book*.

blow things up. I love teaching kids about the science that I use in my work. There are few things as thrilling as learning new ideas. When you uncover the secrets of how the universe functions, you become able to change the world to meet your needs, as Edison did when he created his light bulb.

I can only imagine how you will use your new knowledge of science, but I know that your ideas will play an important role in progress, and I feel lucky to be part of your discovery process.

I hope you enjoy learning how science is used in movie stunts and effects, and I am eager to see what you'll create from your imagination, knowledge, skills and effort.

Scene One, Take One

My name is Steve Wolf, and I have the most exciting job in the world.

I set up stunts and special effects for movies and television shows. I burn down buildings, blow up cars, jump off cliffs, make rain, wind and snow, work with famous movie stars, and get paid for it. And I do it all using science and safety. I base the special effects and stunts I coordinate for movies on simple science concepts I learned in school. I'll show you many of the ways I use science and safety on movie sets.

When I was working on *The Firm* with Tom Cruise, I started thinking about how much money movie stars make. Many of them earn more than $100,000 a day. If you made that each day you came to school, I'm sure you wouldn't miss many days. In a single day movie stars can make what it takes hard-working teachers years and years to earn.

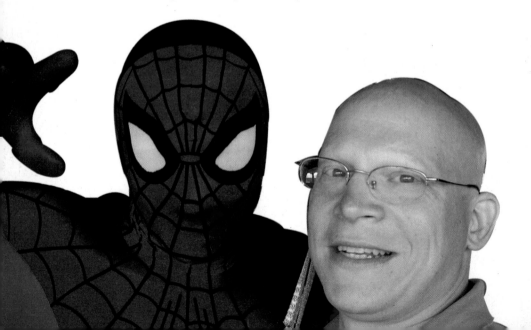

If the star of a movie is sick for a day, the crew of hundreds of people can be left with nothing to do, so missing work creates an expensive problem. I wanted to know how movie stars made sure they never miss work, so I studied their habits and learned six important movie star tips...

Movie Star Tips

1. Eat foods that are healthy for you.
Eat fruits instead of candy.
Drink water instead of soda.
Drink water throughout the day.
Eat more vegetables.
Avoid fried and fatty foods and snacks.

2. Get a good night's sleep every night.
Many actors are in bed by 8:30 on work nights. Relax your mind, away from television and video games, in natural outdoor surroundings whenever you can.

3. Stay away from drugs and alcohol.
Keep your mind and body strong and ready for work.

4. Exercise for at least thirty minutes every day.

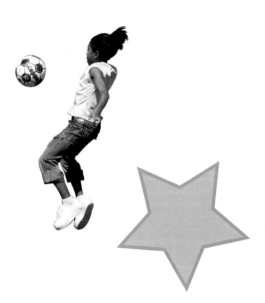

5. Stay away from cigarettes, smoke, and tobacco products.
They are extremely unhealthy (and disgusting).

6. Maintain a positive attitude about your work and toward the people with whom you work.
Be professional; polite, prepared, pleasant and eager to put in a good day's work.

States of Matter

As I read the screenplay for *The Firm* I noticed we were to film a scene in a smoky restaurant. I knew right away we had a science and safety challenge on our hands. Neither Tom, nor I, nor the rest of the crew wanted to be in a room full of smoke. The challenge was to make it look like we were in a room full of smoke, but without having any real smoke. I decided to use a smoke machine that works off the simple principle of science called *states of matter*.

The Three Most Common States of Matter

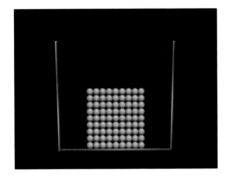

Solids are materials that hold their own shape. The molecules in a solid stay close to each other and hardly move at all.

The molecules that make up liquids usually stay close together, but are free to move around and slip and slide passed each other.

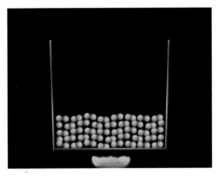

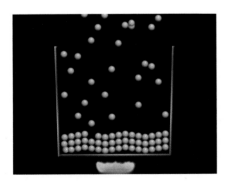

In a gas the molecules fly around freely and will spread out as far from each other as they can.

Scientists divide the universe into two basic components: energy and matter. Energy consists of things like heat, light, electricity, magnetism and radiation. Everything else in the universe is stuff. Scientists call all the stuff the world is made of *matter.*

Matter is anything in the universe that takes up space or has mass. Generally, it's the stuff that can be touched. Much the way ice cream comes in three basic flavors, chocolate, vanilla and strawberry, the matter that makes up the universe is usually found in one of three "flavors" as well. Most often we find matter as a solid, a liquid, or a gas. It also comes in forms like plasma, gels and aero gels, but the vast majority of matter on earth exists in one of the three most common states: solids, liquids and gases.

Ice is a solid. **Water is a liquid.** **Steam is a gas.**

One of the really neat things about solids, liquids and gases is that very often the same material can exist in all three states depending simply upon how much energy is in it. So you can take a solid, like an ice cube, which holds its own shape, add heat to it, and turn it into a liquid. If you take that liquid, which we call water, and you add more heat to it, you can turn it into a gas called steam.

Plasma

The sun and other stars are made from matter in the plasma state. Plasma contains much more energy than gas. As that energy is released it gives us heat and light. It would be very difficult to make movies without light, not to mention that life on our planet would die without sunlight. While plasma is unusual on earth, most of the visible matter in the universe probably exists in the plasma state.

Changes in States of Matter

Here's how the smoke machine works. It takes a harmless liquid and adds heat to it to turn it into a gas. When you take the liquid, and you turn it into a gas, you'd be amazed at how much it expands. In fact, just a few drops of liquid, with its closely packed molecules, when turned into a gas, will form enough gas to fill a room with fake smoke. The smoky look created by the smoke machine looks very real in the movie, but it's harmless to breath. (I once read that long-term exposure to this kind of smoke can cause hair loss, but I don't believe that.)

Smoke machines like this F-100 from High End Systems are one tool we use to create gases from liquids.

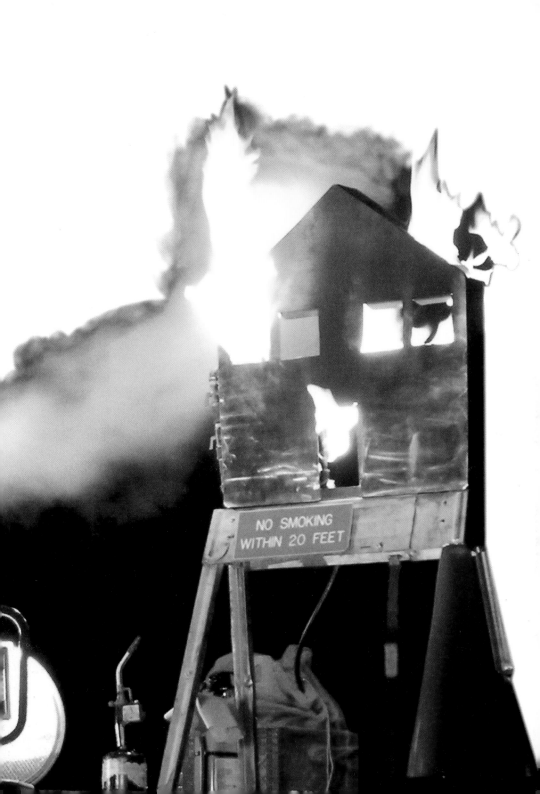

NO SMOKING
WITHIN 20 FEET

Fire & Chemical Reactions

Now I'm sure you've heard an expression about smoke, "Where there's smoke, there's fire!" Whether it's for a candle, a fireplace, or a building on fire, I have to make fire very often in movies. Making fire is much like performing any science experiment; you need ingredients and procedures. Just as if I were baking a cake, I would need butter, flour, sugar and eggs, an oven to provide heat and a recipe to follow, when I'm making a fire I need four components.

The varied colors of these fires result from using different fuels. Burning fuel reactions create light at many different frequencies.

Fuel
+ Oxygen
+ Heat
+ Chemical Reaction

FIRE!

To make fire you have to have fuel, oxygen, heat and a chemical reaction. When you bring together fuel, oxygen, heat and a chemical reaction, you get fire! Fuel is anything that burns. Oxygen is a gas in the air around us we need in order to live. Heat excites the molecules of the fuel and the oxygen, bringing them together in a way that they can react with each other. The chemical reaction allows the fuel and the oxygen to combine chemically and make new products. The ingredients that we use in a chemical reaction are called reactants. After the reactants have burned they make something new. The new stuff is called the *product* of the reaction.

Reactant
+ Reactant

Products of Reaction

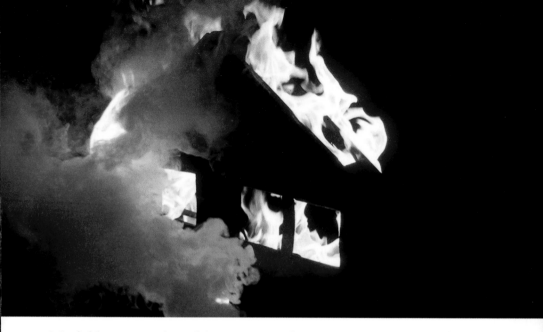

Model house used in the Science in the Movies demonstration.

Most of the time when we burn a house down in a movie we don't use a real house because real houses burn down in about twenty minutes, and filming scenes with burning buildings can take days or even weeks. If we were to use a real house we would lose our movie set long before we were finished filming.

We often have to build our movie house out of materials that are non-flammable. Nonflammable means something that won't easily burn. One material that won't easily burn is steel. By building our movie house out of steel, and covering it with siding made of concrete, we're able to create the look of a real house, but it can't really burn down.

For the fuel that is actually burning, we use a gas called propane. If you have ever seen a television show called *King of the Hill* then you know all about propane and propane accessories. The fuel that we use, the propane, is stored in metal containers. A valve is used to control the flow of propane gas into the house.

I created this full size burning house for
an episode of "America's Most Wanted."

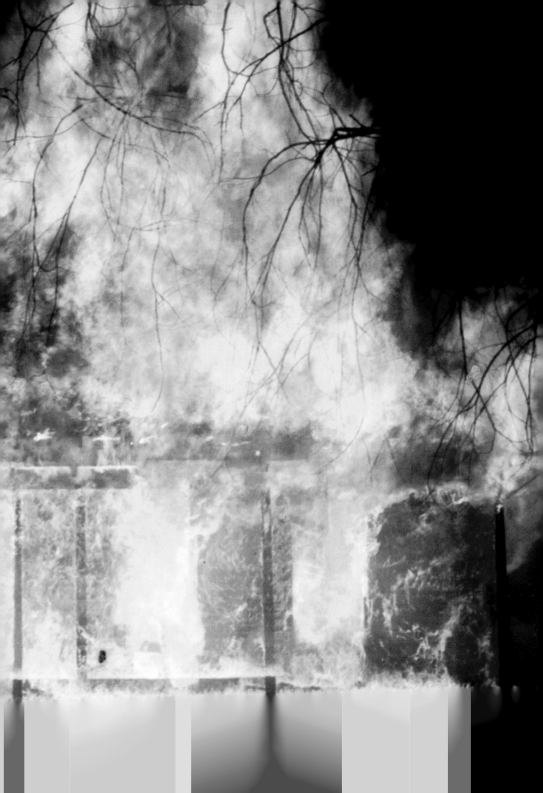

Fluids

A valve is a simple mechanical device that controls the flow of a fluid. In case you're not sure what a fluid is, I'll give you two hints. The first hint is that two out of the three states of matter are fluids. The second hint is that solids are not one of them. So, liquids and gases are fluids. A simple rule about fluids is that fluids take the shape of the container into which you place them. If you pour water into a glass, it takes the shape of the glass, so it's a fluid. If you blow air into a balloon, the air takes the shape of the balloon, so it's a fluid. No matter what you put a brick into, it retains the shape of a brick, so it's not a fluid, it's a solid. While you might think of valves as devices for scientists, an ordinary bathroom or kitchen faucet is a valve. If you brushed your teeth this morning, you've already used a valve today.

When I turn the valve on the propane tank, I'm allowing propane that is under pressure to escape from the tank and pass through hoses and pipes into the burning house.

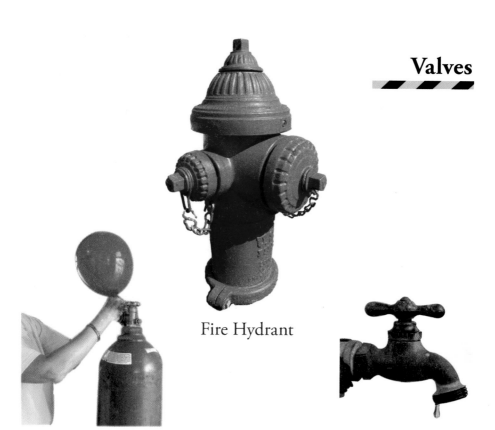

Fire Hydrant

Helium Tank Valve

Water Hose Valve

Sink Faucet

Incidentally, most of the propane in the tank is in the form of a liquid that evaporates into a gas as we use it. It takes heat to turn the liquid into a gas, so the tank gets colder as we use it. The tank usually gets so cold that water vapor in the air condenses on the tank. The temperature at which this occurs is called the dew point. This is called condensation. The condensation forms a line on the outside of the tank that lets us see how much propane is in it.

When we allow the propane gas to come out the windows of the house we're "burning" to mix with oxygen, and I add some heat to start a chemical reaction, I can immediately start a fire.

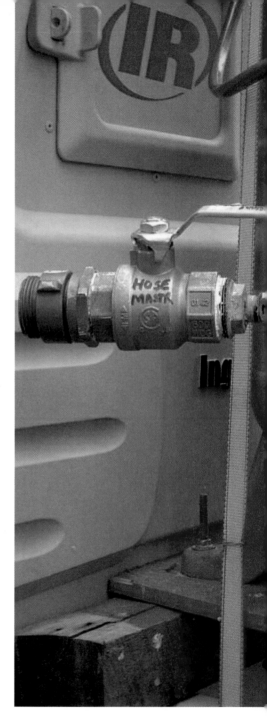

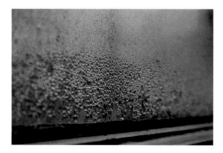

Condensation

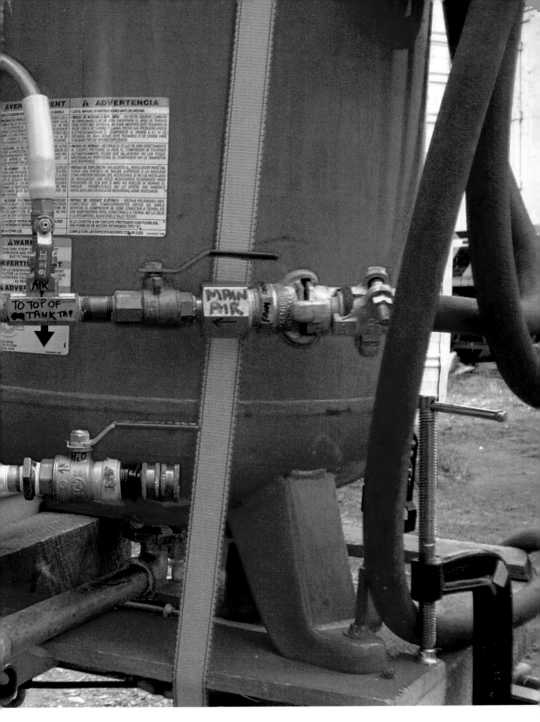

Valves on a snow machine

Depending on how much fuel I supply to the fire, by opening and closing valves, I can make the fire bigger or smaller, or I can move it from one part of the building to another.

Knowing how fuel, oxygen, heat and chemical reactions make fire allows me to create the appearance of a dangerous and out of control fire, but, in fact, I can control every aspect of the fire. Special effects people use science to safely create the illusion of danger.

I mentioned that it takes fuel, oxygen, heat and a chemical reaction to *make* a fire, and it also takes fuel, oxygen, heat and a chemical reaction to *maintain* a fire. If at any time we remove any one of those components, the fire goes out. When the director tells me that fire is no longer needed, (by yelling "Cut!") I can put it out instantly by simply removing the fuel. I do this by closing a valve.

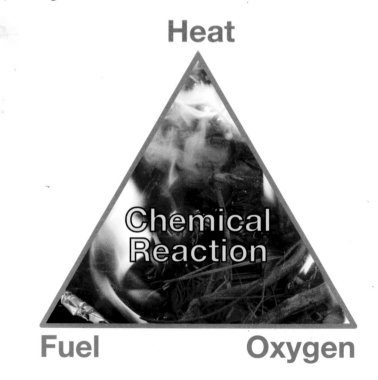

Heat

Chemical Reaction

Fuel

Oxygen

Stunt woman Cheryl Duncan leaps to safety from this exploding building.

Robert Holmes uses a special rig to shoot flames for a commercial. Note his leather gloves, short sleeve shirt and protective eye wear.

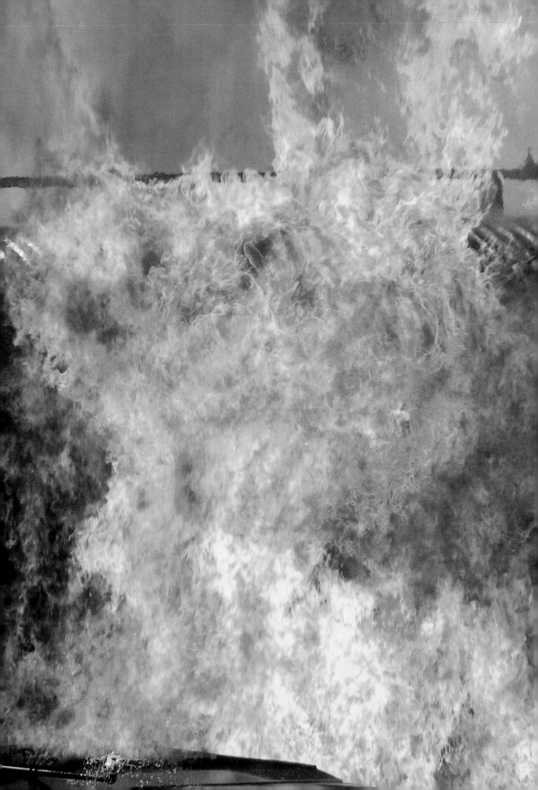

Combining Systems

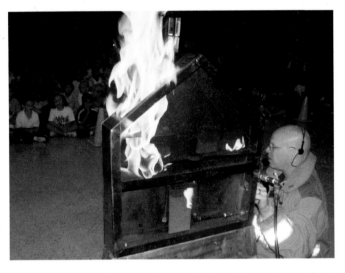

I can turn movie fires on and off as often as I need to during the day simply by controlling the flow of fuel. But what's missing here? There's hardly any smoke coming from this fire. If we want smoke we'll have to add it by using a smoke machine. When I combine fuel, oxygen, heat and the chemical reaction to make the fire, along with adding heat to a liquid to make smoke, I'm combining two systems—one that combines fuel, oxygen, heat and a chemical reaction to create fire, with a second system that adds heat to a liquid to make a gas, to make the look of a smoky fire.

Now take a closer look at this demonstration house. Before burning it, it was nice and clean. Now it is all dirty. It has this black stuff all over it. Do you know what that is? It's evidence of a chemical reaction. This black stuff wasn't there before, but when we combined the fuel and oxygen we made this stuff. Do you know what this black stuff is? It's an element called carbon. Do you know what it could do to you? No. It won't kill you. But it could get your skin and your clothes very dirty.

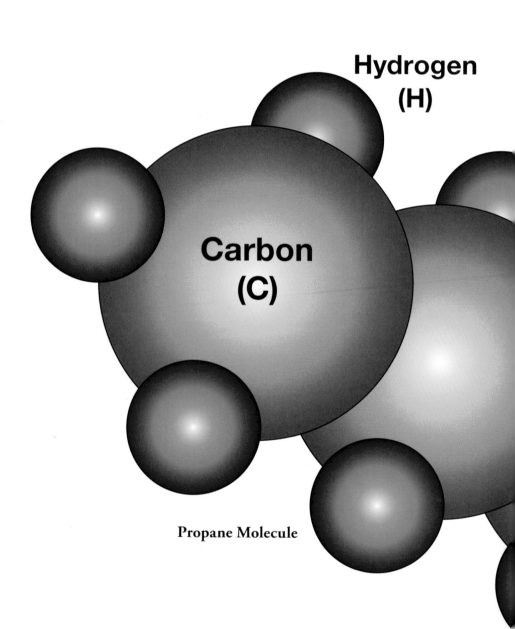

Hydrogen (H)

Carbon (C)

Propane Molecule

Carbon & Hydrocarbons

Have you heard of some fuels called *hydrocarbons*? This means that the elements that make up this fuel are hydrogen and carbon. When we chemically combine these fuels with oxygen, and rearrange the molecules through the process of burning, we're making new things. The carbon soot on the demonstration house is one of the new things we made. Some of the carbon molecules in the fuel broke loose from the hydrogen atoms and stuck to the house. Carbon is a good thing.

Do you know where you can find lots of carbon? Look in the mirror. You contain carbon. Every cell in your body is made using carbon molecules. In fact, every living thing on this planet is made using carbon molecules. It is in people, dogs, cats, lettuce, tomatoes and even teachers. Since it's in every living thing, scientists call life on earth "carbon-based life." This is good stuff.

All living things on Earth contain carbon.

Kids contain carbon, too!

$$C_3H_8 + 5\,O_2 \longrightarrow 3\,CO_2 + 4\,H_2O$$

Propane Oxygen Carbon Water
Dioxide

This is the formula for a clean burning propane flame, which produces only carbon dioxide and water vapor. To burn cleanly, there must be plenty of oxygen available to the fire. This process is great if you are cooking, and produces a blue flame, but it doesn't look very impressive in movies.

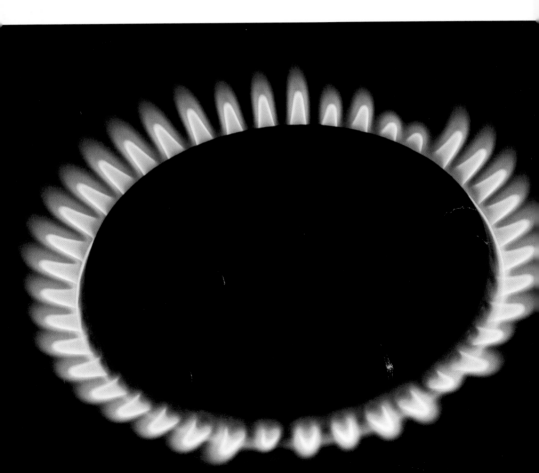

To make bright red and yellow flame with lots of carbon soot, which looks more exciting in movies, we need to keep the reaction from being complete, so we deprive the reaction of some oxygen. This produces loose carbon in addition to the carbon dioxide and water vapor. The hot carbon particles in the flame create the red and yellow color, and also give off black smoke.

$$C_3H_8 + 4\ O_2 \longrightarrow 2\ CO_2 + 4\ H_2O + C$$

Propane Oxygen Carbon Water Carbon
 Dioxide

SAFETY CHECK

Carbon monoxide

There's another product of our chemical reaction that is not so good. Some of the carbon molecules in the fuel joined with oxygen molecules from the air to make a poison gas called carbon monoxide. When you have a fire in a house, enormous amounts of carbon monoxide are created, and it *can* kill you. Carbon monoxide has no smell so you don't know when it's around you unless you have a carbon monoxide detector in your home. You saw from the smoke machine how quickly gases spread when we start making them, so it's extremely important to remember: **If there's a fire in your home get out of the house IMMEDIATELY,** and then call 911 from a cordless or cellular phone, or from a neighbor's house.

Keep fresh batteries in your hazardous gas and smoke detectors by changing the batteries twice a year when you reset your clocks. Because carbon monoxide is heavier than air, the carbon monoxide detectors must be placed near the ground, while smoke detectors should be placed near the ceiling.

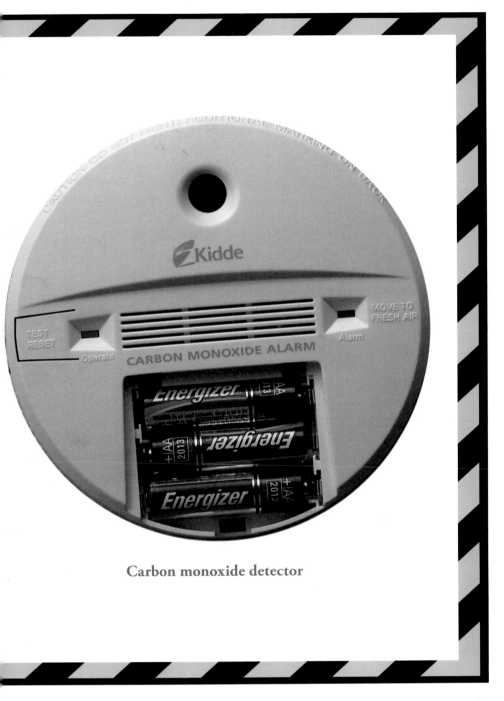

Carbon monoxide detector

Hemoglobin

The reason carbon monoxide is poisonous is because it forms very strong attachments to the hemoglobin in our blood, which normally carries oxygen. When carbon monoxide molecules attach to the hemoglobin molecules on our red blood cells, there's no place for the oxygen to attach; so if you breathe carbon monoxide, you suffocate from the inside because your cells stop getting the oxygen they need to keep you alive. Carbon monoxide sticks to hemoglobin 40 times better than oxygen does. People who have been exposed to high levels of carbon monoxide usually turn bright red, so if you find someone passed out and bright red it could be a warning that you're in an area with dangerous levels of carbon monoxide.

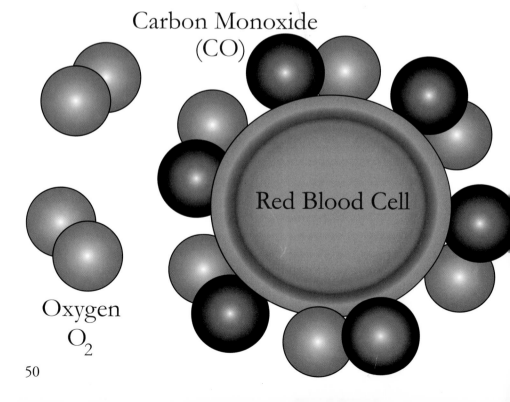

Carbon Monoxide
(CO)

Red Blood Cell

Oxygen
O_2

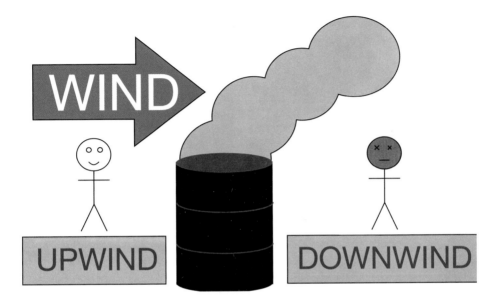

If you suspect that you are in an area with dangerous gases, get to fresh air immediately. If you can tell where the gas is coming from, get "upwind" of the source.

Many times when you have a house on fire in a movie, directors come up with the idea that the movie would be much more exciting if someone were trapped in the house. Not only are they trapped in the house, they're up on the roof, with flames all around them! What do you think the directors want them to do to escape from the fire? Jump off the building!

Gravity

When a stunt person falls, what do you think does the work of getting the stunt person from the roof to the ground… does the stunt person have to push off hard enough to launch themselves all the way to the ground? No. All they have to do is take one little step, or even just lean forward until they are off balance, and then gravity takes over and does all the work. Now that's a great deal! Gravity does all the work, and the stunt person gets to keep all the money. It's great to get paid for work done by gravity.

See the Fall Table on page 183 for information about falling.

Compressing Gases

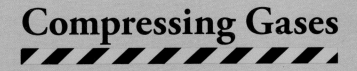

So we're going to have a stunt person falling. They might be falling one or two stories, or they might be falling several hundred feet. Do you think it's dangerous to fall two or three hundred feet? I've been setting up stunts for nineteen years and I've never seen anyone get hurt falling. Now, I have seen some people get killed landing, but that's a whole other story. Landing is the dangerous part, but as long as you're falling you're safe. In fact, we have a saying in the stunt business, "It's not the fall that kills you, it's the sudden stop at the bottom." We want to make sure that whenever a stunt person is falling they always have a nice soft landing. We want to make sure they never have what I call a "Humpty Dumpty" landing.

The way we make sure stunt people always have a nice soft landing is by giving them something soft on which to land. We use a device called an airbag, which is like a giant air mattress. When you land on it, it goes squishhhhh... and slows down your landing so you don't splat like an egg on the sidewalk. The reason that you get such a nice soft landing when you land on air is because air is a gas, and gases are compressible, like springs. When you compress air, you're forcing the molecules closer together.

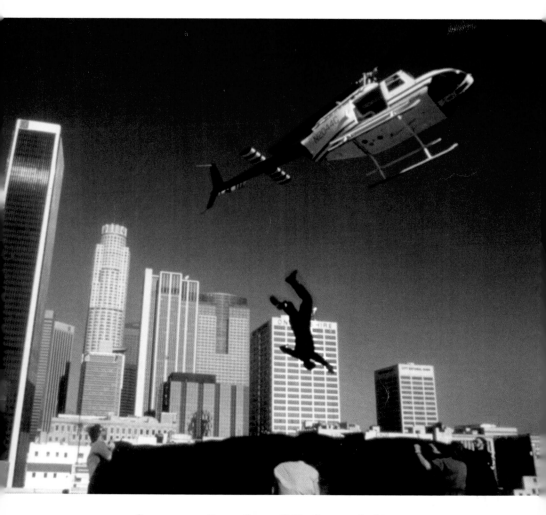

Stunt man Scott Leva falls from a helicopter.

Components of Air

In order to do exact calculations about how compressible the airbag is, you need to know what kind of molecules are inside the airbag. Ordinary breathing air at the earth's surface is made up of 78 percent nitrogen and 21 percent oxygen. Carbon dioxide, hydrogen, argon, helium, neon, krypton and xenon make up about one percent of air.

Carbon Dioxide, Hydrogen, Argon, Helium, Neon, Krypton and Xenon

So, back to our stunt. We have gravity doing all the work of getting the stunt person from the top of the building down to the ground, and we have an airbag to slowly absorb the energy of the falling stunt person and give them a nice safe landing. Now, there's just one thing left to figure out; how to get back up to do it again. Unlike a daredevil act, where the performer might get hurt, a stunt person is a professional who has to be able to perform the same stunt repeatedly without getting hurt. We're not trying to create danger; we're safely using science to create the illusion of danger.

Einstein's Rule of Simplicity

How do we get a stunt performer back up to the top of the roof? Well, if we are filming in a skyscraper downtown, all we have to do is put them in an elevator and press a button. Einstein said when we're looking for a solution to a problem, and we have several choices, the simplest choice is usually the best. But sometimes we're filming at the edge of a cliff or at the top of a crevasse and there is no elevator, so we have to have another way to get our stunt person back up to the top. The way that we do that is using *simple machines*.

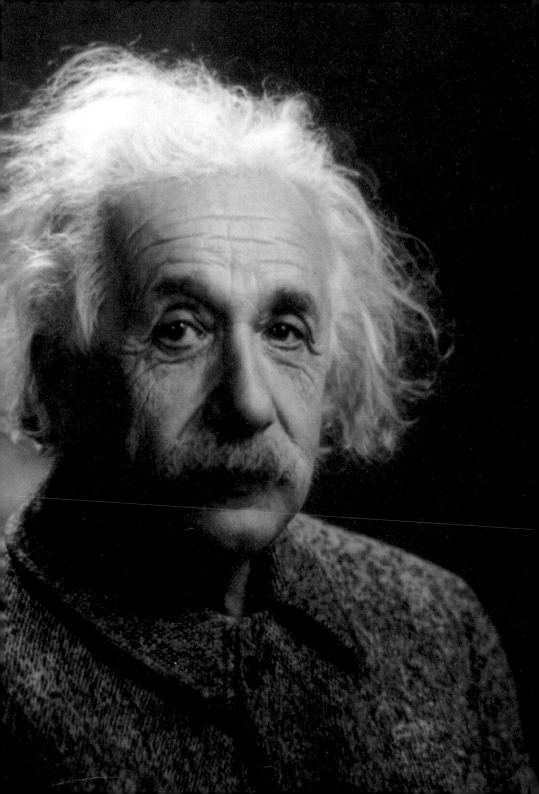

Simple Machines

From a practical standpoint, simple machines are devices that multiply our effort. They help us get really hard things done by breaking the task up over time or distance, so that difficult tasks end up becoming a series of small easy tasks.

There are six simple machines. They are levers, ramps (sometimes called "inclined planes" by people who want science to sound more confusing), screws, wedges, wheels and axles, and my favorite—pulleys. Most complicated machinery is really just a combination of simple machines. Stunts would be impossible were it not for simple machines. We couldn't do car jumps without ramps. We wouldn't even have cars at all, were it not for wheels and axles. We couldn't make people fly without pulleys.

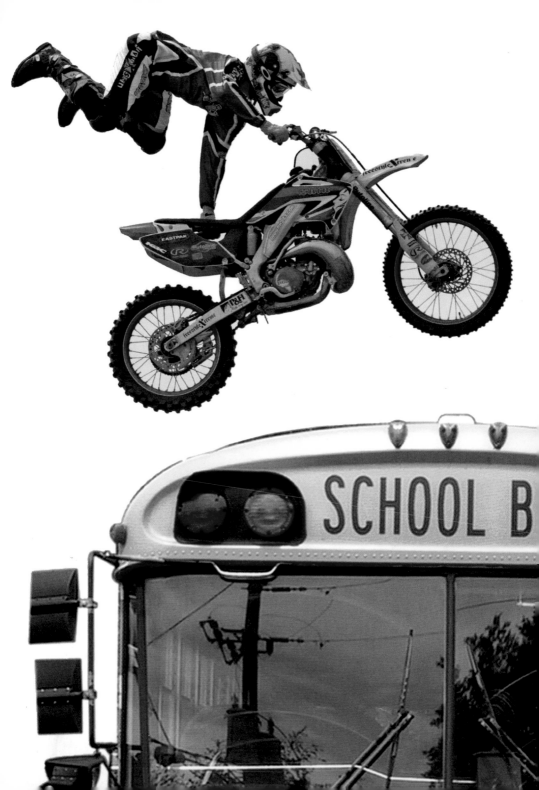

Examples of
Simple Machines

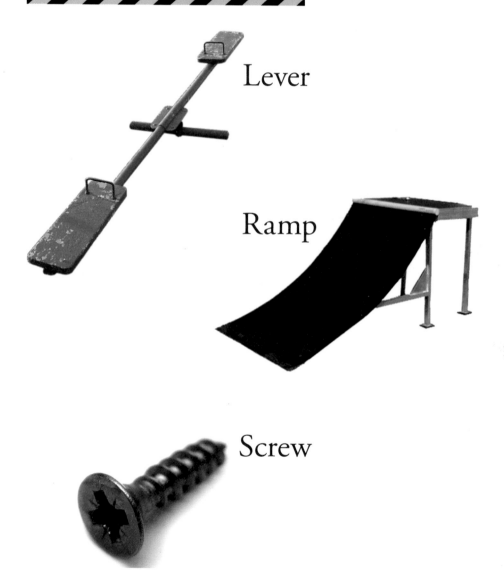

Lever

Ramp

Screw

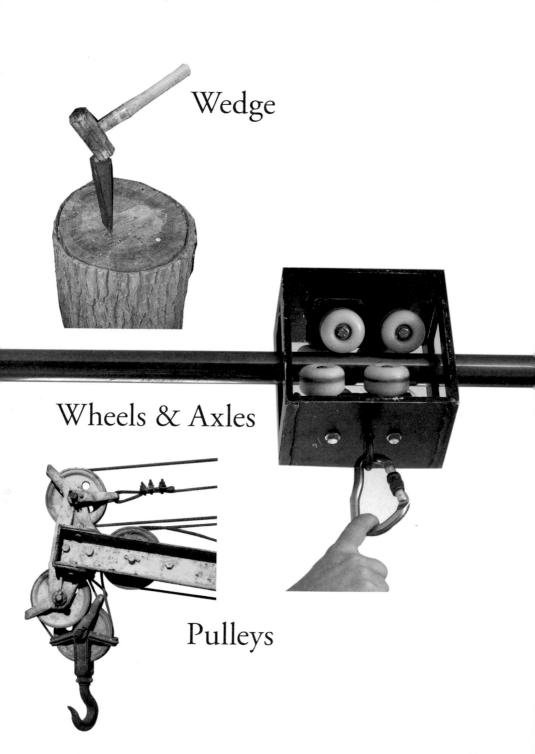

Wedge

Wheels & Axles

Pulleys

Pulleys

I first read about pulleys when I was in fourth grade, and I learned that by using pulleys you could effectively multiply your strength to lift things that were heavier than you are. Now, I was a pretty small kid in fourth grade, so the idea of being able to lift things that were heavier than I was sounded pretty cool.

I was so excited about pulleys that I got an after school job so I could make money to buy some pulleys, some rope and a harness. I'll never forget the day I came home from the store with my pulleys. I set them up in a big oak tree in my backyard. I attached five pulleys to a big branch and four pulleys to a harness. I threaded all the pulleys together using a rope. Then I ran into my house to find something to lift. The first thing I came across was… my mom! I told her I had learned about pulleys in school and I had bought a bunch of them and I asked her to come outside and let me see if they really worked. Well, she looked at me like I was nuts, but then she said, "Yes!" She came outside and stepped into the harness, I

A second grade girl hoists her principal up in the air using pulleys during a Science in the Movies show. Not only does this prove that pulleys multiply effort, but it proves that a girl, with just one hand, can easily do the work of many men.

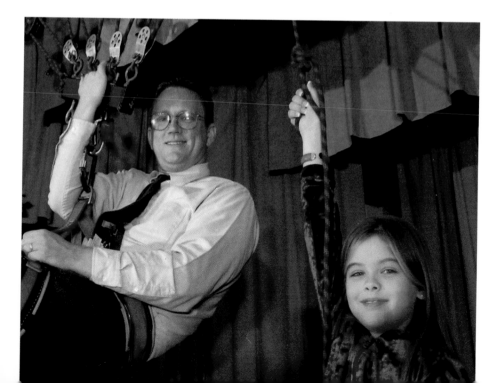

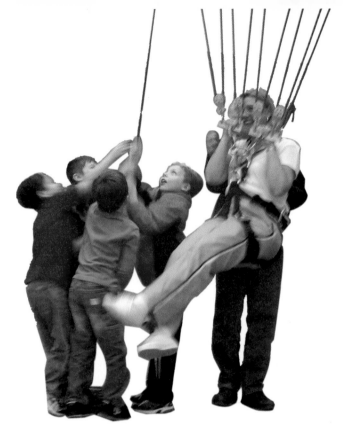

started pulling on the rope, she started going up. She was screaming, I was laughing, and I lifted her about 20 feet in the air. It was so exciting, and I had so much fun that I've been lifting people with pulleys ever since.

Here's how pulleys work. A pulley is just a wheel with an axle running through it that changes the direction and movement of a rope that is wrapped over the wheel. If I have a rope running through one pulley, and I pull down on one side of the rope, the other side of the rope goes up. If I pull down on one side with about 10 pounds of force, the other side goes up with about 10 pounds of force. So one pulley doesn't multiply your strength, it just changes the direction of the force. What would happen if I push on the rope? Nothing. Why? Because these are not pushies. They are pulleys. "Pushies" are over-assertive people who don't get much done

because they don't know how to work together. But pulleys get lots of work done, and they do it easily, because they pull together.

Pulleys can effectively multiply your effort by the number of pulleys you use. Therefore, if you have a rig that uses nine pulleys, it can multiply your effort nine times. It's as if the pulleys make you nine times stronger than you are! When we're using machines to multiply our strength, or allow us to lift or move things easily that would normally be difficult or impossible for us to move, we call the benefit "mechanical advantage." If a simple machine or collection of simple machines multiply the force that you apply

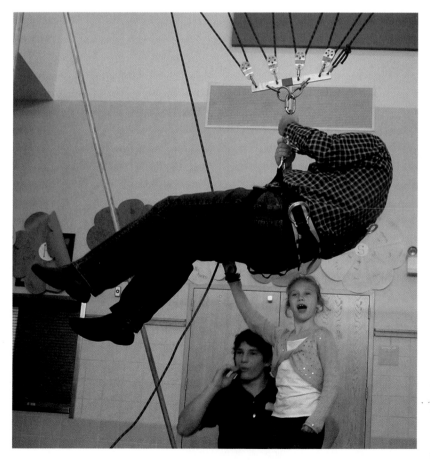

by, say, nine times, then we would say that it has a mechanical advantage of nine to one. Some people call mechanical advantage "work in, work out; effort in, work out" or other names, but the idea is the same. You never really get one hundred percent of the benefits of simple machines in real life that you get in calculations, because of friction and other lost effort, but it gets you pretty close.

An easy way to figure out the mechanical advantage of a pulley system is to count the number of ropes that connect the pulleys at the top and the pulleys at the bottom.

If the item that you are lifting, what we call "the load," is connected to nine rope segments, then all nine rope segments need to be raised by 1 foot in order to raise the load by 1 foot. To do this you have to pull 9 feet of slack out of the lifting rope.

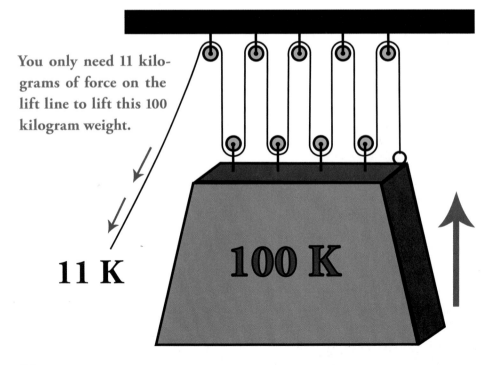

You only need 11 kilograms of force on the lift line to lift this 100 kilogram weight.

11 K

100 K

This massive pulley
could lift an entire
movie studio.

Tensile Strength

The amount of tension or "pulling" you can put on something without breaking it is a property of matter called tensile strength. The tensile strength of the nylon webbing harnesses are made of is about 6,000 pounds. Stunt harnesses are made of the same kind of material as seat belts, so you have a chance to wear professional grade stunt equipment every time you get in a car, just by putting on your seat belt.

Tensile strength is partly a function of the strength of the bonds between molecules. These are called **forces of attraction**. Steel shackles and nylon ropes are strong because these forces of attraction are strong.

Tension

When we lift people in movies, such as *Spider-Man*, the actor is lifted or flown around wearing a harness. The harness is made of very strong material called nylon webbing. We say it is strong because it will hold up a lot of weight without breaking. Tension is a measure of the "pull" within a system. In a vertical rig, the tension is equal to the weight of the load. In horizontal rigging, such as a zipline, the tension can be as much as ten times the weight of the load. The load is usually the weight of the stunt person plus whatever dynamic forces he exerts on the rigging by moving.

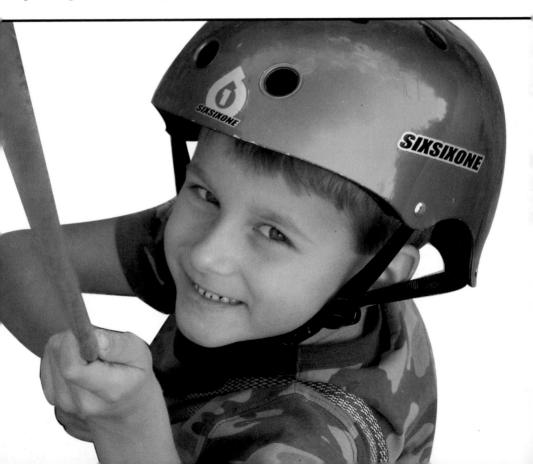

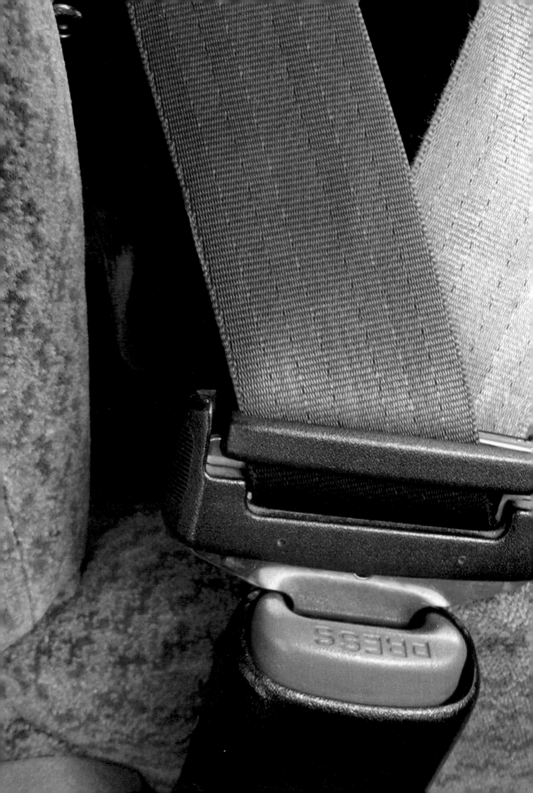

SAFETY CHECK

Seat Belts

The most important piece of safety gear you can wear everyday is your seat belt. Most people don't realize that a car accident involves several collisions—one between the car and what it strikes, and one between the passengers and the car in which they are riding. You can reduce your likelihood of being injured while riding in a car by making sure you are securely buckled up. Also, because many car accidents take place in parking lots, don't wait until you are on the road to put your seat belt on. Have your seat belt secured before the car starts moving.

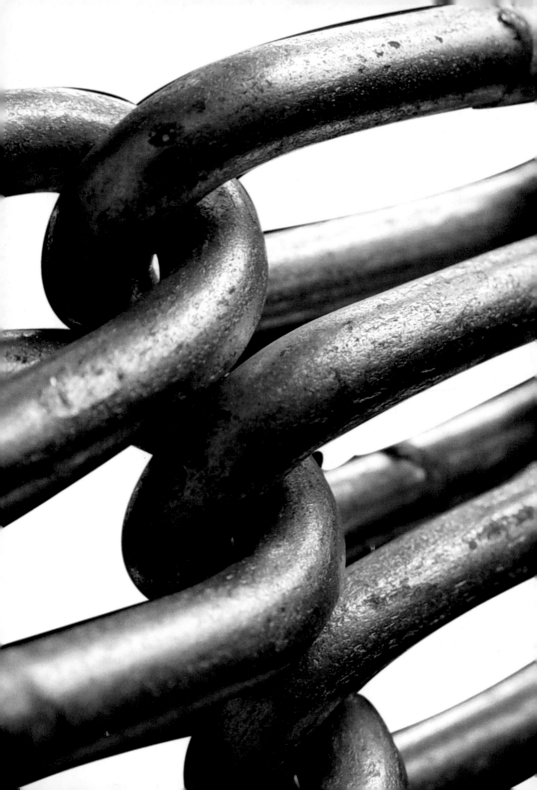

SAFETY CHECK

You Might Be The Weakest Link

Just because a harness can hold 6,000 pounds doesn't mean the entire system can support 6,000 pounds. When you look at the strength of a system, you have to look at the strength of the weakest part. There is an old expression that says a chain is only as strong as its weakest link. The weakest link in a system might not be simply a mechanical part. All of the parts could be perfect but they might be put together incorrectly or improperly fastened. Stunt people have to constantly check and recheck not only their equipment, but also their procedures. A really good way to check your procedures is to work in teams. I like to do my work, and then have someone check it to see if I've made any mistakes.

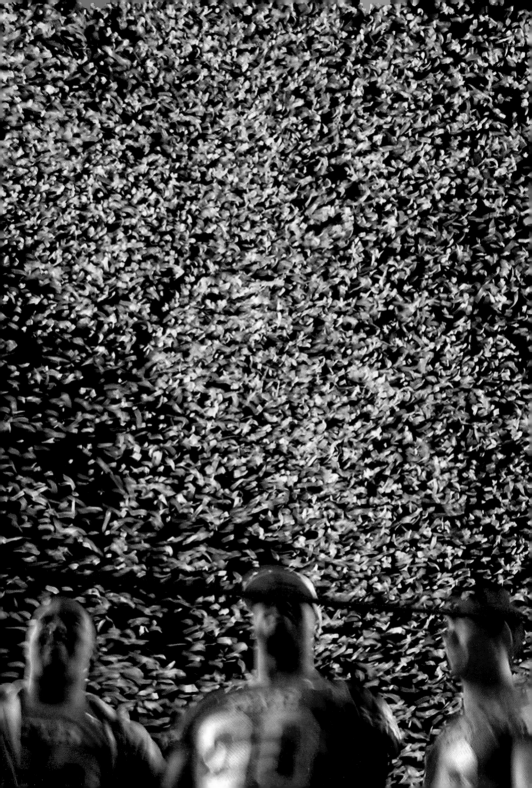

Blowing Things Up

Special effects crews are called upon to blow things up in movies. When you blow something up, that is literally what you're doing. You are *blowing* something up. Blowing on something means that you're pushing forcefully against it using air. If you blow something away, you're pushing laterally (sideways) against it with air until it moves away. If you're blowing something up you're pushing against it vertically from below, with an upward moving column of air that pushes the item up.

So, if blowing something up is nothing more than pushing up against it with a bunch of air, the real science question becomes, "Where do we get the air?" There are several ways we can get air to blow things up.

Air is used to blow confetti up for this Rose Bowl victory celebration.

Air Cannons

One very simple method of "blowing things up" is to use a device called an air cannon. An air cannon consists of a compressor that forces air into a tank. The air is held in the tank by a valve. When the valve is opened the air in the tank is suddenly released into a barrel that contains the item we want to blow up. When the compressor forces air into the tank, millions and millions of air molecules are squeezed into a small space. The more air molecules we place in the metal tank, the more pressure they exert against the sides of the tank.

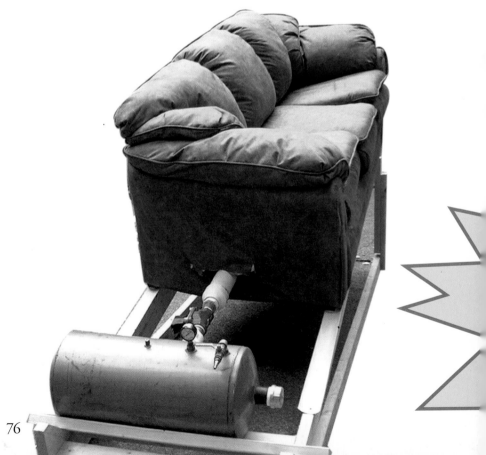

Pressure & Force

Pressure is a force acting against a surface. It acts equally in all directions so the air trapped in the tank is pushing equally against the top, bottom, back and sides of the tank. So while there's a great deal of movement and energy inside the tank, no work is done.

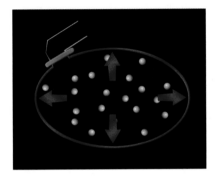

In order to get work from the system, the potential energy of the pressure must be focused in one direction. When the pressure moves in one direction, it ceases to be simply a pressure and becomes a force. Forces act in one direction.

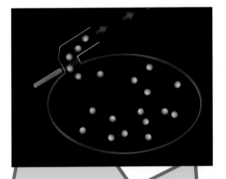

KABOOM!!!

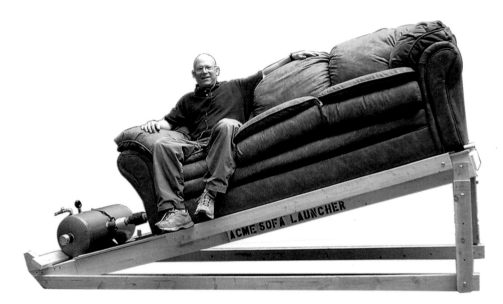

This sofa launcher was used in a commercial. Can you guess which famous coyote inspired my design?

The amount of work that can be done using air pressure is amazing. I once used the force generated by the air in an air cannon to throw a living room sofa through a window and eighty-five feet out onto the lawn of a home. This would be impossible to do by hand... people just aren't that strong.

Time, Distance, Effort & Power

Many machines, like air cannons and pulleys, have something in common. They work on an interplay between time, distance, effort and power, often taking a task requiring a great deal of power and dividing it out over time and distance so that the task is never very difficult at any one time, and the effort is spread out. While throwing a sofa requires a great deal of power, the power is accumulated over the amount of time the compressor spends packing air molecules into the tank. Once all that energy has been stored it can be released all at once.

Air cannons are great for throwing things because, like all good science projects, they are predictable, controllable and repeatable. I can figure out how far and how fast any object will go, based on the weight of the item and the amount of air pressure I put into the tank. The more an item weighs the more pressure I have to use to launch it. If I'm throwing the

same item over and over again, I can change how far it goes by changing the air pressure in the tank. The more pressure I use, the more forcefully I can launch something. If I keep the pressure constant from one "take" to the next, I know that the object I'm launching will hit the same spot every time. This is very helpful if you need to film a close-up of one item hitting another, such as a baseball hitting a bat. The air cannon can throw the ball at exactly the same spot every time, so we know where to point the camera. It would be very difficult, and not very safe, if we tried to throw a ball by hand with so many people around. Using science makes us safer.

Machines work on an interplay between Time, Power, Effort and Distance.

Ron Gilbert checks the bucket of this huge machine

Fire Stunts

Fire stunts are among the most dangerous of stunts. People are like toast: you can burn them, but you can't unburn them. There are no second chances when you are working with fire, so this is an area reserved only for highly trained professionals. **Do not play with fire.** Do not try your own fire stunts. You will get hurt, killed, or hurt others if you try this. Stunt people are the only people I know who get set on fire on purpose. However, we are not the only people who are set on fire. People get set on fire every day because they get too close to a stove, a bonfire, a match, a lighter or the candles on a birthday cake.

Stunt performer Tommy Betts takes a full-body burn.

SAFETY CHECK

Stop, Drop and Roll

When I say that people get set on fire, what I really mean is that their clothing is set on fire. Therefore, it is very important to know what to do if your clothing catches fire. We use a method that most of us were taught in first grade, called "Stop, Drop and Roll." You simply stand still, cover your face, drop to the ground and roll like a log, pressing your body as close to the ground as you can. When you press your body against the ground, you are squeezing air away from you. As the air leaves, it takes away the oxygen, and without oxygen, the flames are extinguished.

Stop

Drop

Roll

Insulation

Heat is a form of energy. When you want to block the flow of any kind of energy, whether it's heat, electricity, magnetism, radiation, light or any other form of energy, you use something called an insulator. For every type of energy, there is some material that will insulate, or *resist*, the flow of that energy.

Rubber, sunglasses and jackets are all forms of insulators. However, none of them would keep us from getting burned if we were set on fire. It is very important to choose the right kind of insulator for the job you're doing. If a stunt person is to be set on fire, they will need to choose an insulator that has certain properties.

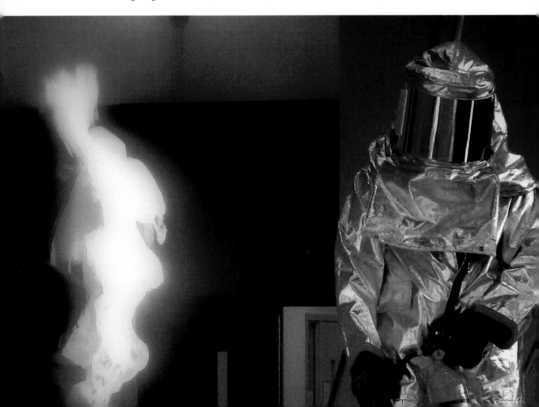

To keep us from getting shocked by the electricity in extension cords, the copper wires that conduct the electricity are covered with rubber, which blocks the flow of electrical energy. When we go out in the sun, we can block some of the light from reaching our eyes by wearing sunglasses. To keep warm on cold days, we wear jackets to hold in heat.

In a fire stunt the insulator must keep the heat *out*. It must also be non-flammable. It has to be flexible, so it can move with you. It has to be thin, so it will hide easily under clothing. That's a lot to ask from one material. Fortunately, there is such an insulator. A scientist named Gary Zeller invented it, and it's called Zel Jel. Dr. Zeller won an academy award for inventing Zel Jel. I learned a great deal working as an apprentice for Dr. Zeller, who taught me all about the exciting world of special effects.

By the way, a gel is a state of matter that is not quite a liquid, and not quite a solid: it's somewhere in between the two.

Equipped with this unique insulation, it's possible to be on fire without suffering any injury. When you're working with dangerous forms of energy, make sure there is an appropriate insulator between you and the energy.

Remember! People are like toast. You can't unburn them. Never take chances with fire.

Stunt performer Tommy Betts being covered with insulating fire stunt safety gel.

Explosions: More Ways to Blow Things Up

Explosions are probably the most popular special effect. While it's extremely rare to see explosions in "real life," they seem to happen every day in movies.

An explosion is a sudden and violent release of energy from a rapid chemical reaction. The reactants can consist of solids, liquids or gases but the products of the reaction always include gases. The rapid chemical reaction of an explosion creates a tremendous amount of gas, which expands with terrific force, exerting tremendous pressure on its surroundings. When the pressure is released in one direction, it creates a powerful force that can be used to blow up buildings, cars, mountains or anything else that a script

writer can imagine. Depending on the type of explosion that is needed, it can either simply throw things or create a huge fireball as well.

Safely creating explosions for movies calls on knowledge of all the physical sciences at once.

Exploding something is often referred to as "blowing it up." As I said earlier, the reason we call it "blowing" it up is because that is literally what we're doing. When we blow up a car, we put gas underneath it, and blow upward with that gas so powerfully that we push the car up into the air. Creating a rapidly-expanding, upward-moving column of gas is the final step of an explosion. Now we just have to figure out how to get there.

Most of the science and engineering in special effects is figured out by working backwards. You start out knowing what you want your shot to look like when you are done. Then you work back, step by step, to figure out how to get there. This is a very important concept not just in movie stunts, but in general. Often referred to as "Begin with the end in mind," it was very well

described in a book by Stephen Covey called *The Seven Habits of Highly Effective People* and I recommend that book to anyone. Statesman Henry Kissinger also spoke well of this concept when he said, "If you don't know where you want to end up, every road will get you nowhere."

Now, back to our explosion... I need to create a whole bunch of expanding gas that will create enough force to blow a lot of dirt or a car or house up into the air, or break it into pieces.

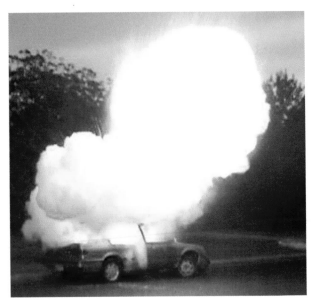

Knowing what chemicals to use and the quantities and methods used to create explosives requires specialized knowledge in chemistry. We have to use chemicals that react together very quickly. The speed of the reaction is very important to developing the amount of force we need to create.

If I use heat to trigger a reaction between a fuel and oxygen, we would describe that reaction as "burning." If the reaction moves from one end of the fuel to the other at a speed that is greater than the speed of sound, which is around 1,100 feet per second, then we say the chemicals are not simply burning, they are detonating. Fuels that react with oxygen and burn faster than the speed of sound are called explosives. When

90

explosives detonate, a shock wave is created that carries the reaction through the chemicals that are reacting. Many explosives react at speeds upwards of 22,000 feet per second, or more than 15,000 miles per hour. That's fast enough to go around the earth in less than two seconds!

Once you have the reactants, commonly known as explosives or pyrotechnics, you have to figure out how to start a chemical reaction. Starting a chemical reaction usually involves adding energy. Many chemical reactions can be started by adding heat.

To trigger the detonation, I need to add heat to the reactants to get the chemical reaction going. The simplest way to do that would be just to point a blow-torch at the chemicals… but then I would have to stand right next to them, and that could be dangerous, especially if I'm expecting to create a violent explosion. So I have to figure out how to apply some heat from far away.

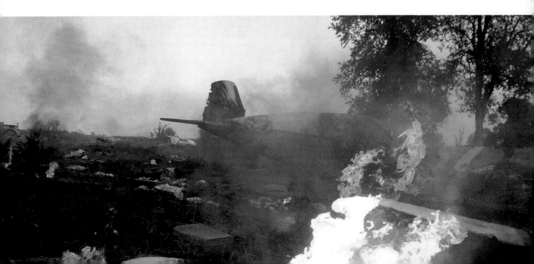

The easiest way to apply heat from a distance is to start with a different form of energy, such as electricity. I can send electricity toward the chemicals, and then turn the electricity into heat. You see, one of the amazing things about energy is that you can turn it from one form into another. Isaac Newton hinted at this in his laws of thermodynamics.

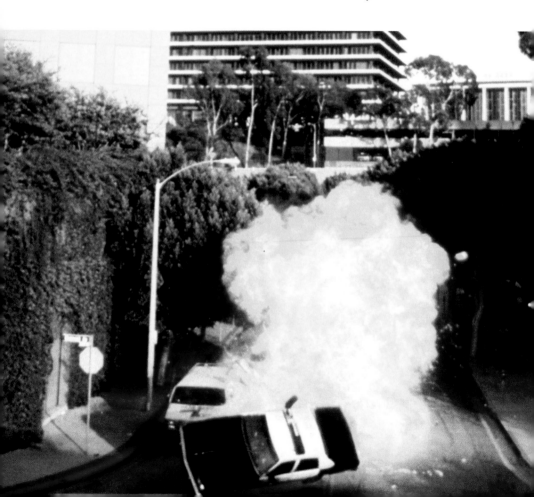

Chemical Reactions

To make a chemical reaction, you begin with two or more chemicals. The chemicals you begin with are called the reactants.

During the reaction, the atoms are rearranged. Energy, in the form of heat and light, is often given off during the reactions used in special effects.

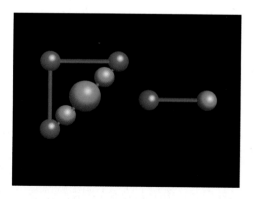

The rearranged molecules form new chemicals called the "products" of the reaction. Often these are soot and expanding gases.

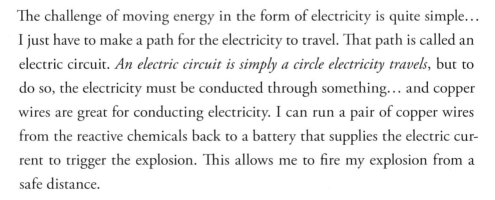

Isaac Newton understood that to make advances in science, he would have to learn what was already known. He said, "If I see far, it is because I stand on the shoulders of giants." Not all discoveries are made by mental giants like Newton, Hooke and Einstein, and most successes are the result of persistent effort. Get started now, and keep at it.

Newton's Second Law of Thermodynamics led to the idea that energy can be changed from one form to another, as occurs when we use electricity to make heat.

The challenge of moving energy in the form of electricity is quite simple... I just have to make a path for the electricity to travel. That path is called an electric circuit. *An electric circuit is simply a circle electricity travels*, but to do so, the electricity must be conducted through something... and copper wires are great for conducting electricity. I can run a pair of copper wires from the reactive chemicals back to a battery that supplies the electric current to trigger the explosion. This allows me to fire my explosion from a safe distance.

94

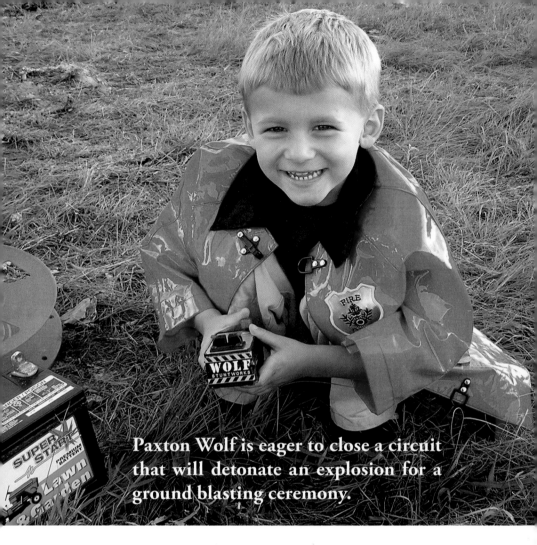

Paxton Wolf is eager to close a circuit that will detonate an explosion for a ground blasting ceremony.

When I touch the wires to the terminals of the battery, the electrical charge gathered at the negative terminal of the battery creates a current through one wire, down to the explosive, and then back through the other wire to the positive terminal of the battery. Although there is a lot of current traveling through the wire, there is plenty of room for it, because the particles creating the current (*electrons*) are tiny and the wire is large. It's as if a bunch of skaters were traveling down a fifty lane highway. There is enough room for everyone. When a wire is wide

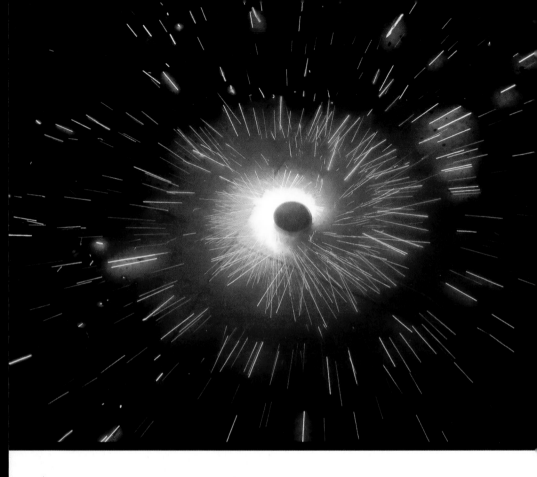

enough for all the electricity to flow through it without too many electrons bumping into each other, we say that the resistance within the circuit is very low.

This brings us to the next step—converting the electricity into heat, so we can start the reaction. By using electricity to generate heat, I can control exactly when the explosion will be triggered. This is very important, because most stunts and special effects require precision timing. If a flower pot is supposed to explode as if it were being shot just as someone runs past it, then I have to complete my electric circuit at precisely the right time. I do that by using an ordinary electric switch. A switch is a very simple

Turning Electricity into Heat

Using a flow of electrons through a wire as a source of energy, we create heat by changing the size of the wire at the part of the circuit where it touches the chemicals. We start with large wires.

When the flow of electrons through large wires comes to the narrow wire, the current can't pass through the narrow wire very easily. This is called resistance.

The resistance generates heat and becomes so intense that the wire itself burns up. The heat from these collisions and the burning wire is so hot that it starts the chemical reaction, detonating the reactants in the explosive.

We created heat by changing the circuit from one of low resistance, where the wires were large, to one of high resistance, where the wires are tiny.

device that simply touches two pieces of conductive materials together… usually two pieces of copper. If the circuit is made too soon, the flower pot would "blow-up" in the stunt performers' face, which would be very dangerous. If the explosion goes off too late, it wouldn't look very exciting. If I don't think I'll be able to time the closing of the switch by hand, I can use a trip wire near the flower pot. As the stunt person runs past the flower pot, she hits a wire with her foot that activates a switch, and that switch triggers the explosion.

What if someone were to accidentally trip over the wire? I wouldn't want the explosive to go off because a lighting technician carried a ladder across the set and unintentionally hit the trip wire. So I need a way to ensure that the trip wire only fires the explosive when I want it to. I do that by adding a second switch, wired in *series,* to the circuit.

A switch creates a gap in a circuit, preventing electricity from completing a circle. It takes one gap to interrupt the circuit. If we have two or more switches in the circuit, they must both be closed to make the circuit complete. Closing the gap using a switch consists of simply turning the switch to the ON position. ON means no gap. OFF means there is a gap that does not conduct electricity.

Using two switches in the same circuit, where both switches must be ON at the same time, is done by

putting two switches in series with each other. For extra safety the firing boxes used to fire explosives often have more than one serial switch, and one of the switches usually must be turned on using a key.

In our explosion, we have one switch attached to the trip wire that the stunt person triggers, and the second switch, called the **arming** switch, which I hold in my hand. When **both** switches are ON, the flower pot will blow up instantly.

So I keep the arming switch in the OFF position until we are ready to film, everyone has stopped moving, the cameras are rolling, and the only person moving is the stunt person running toward the flower pot. That way, nothing happens until it's supposed to.

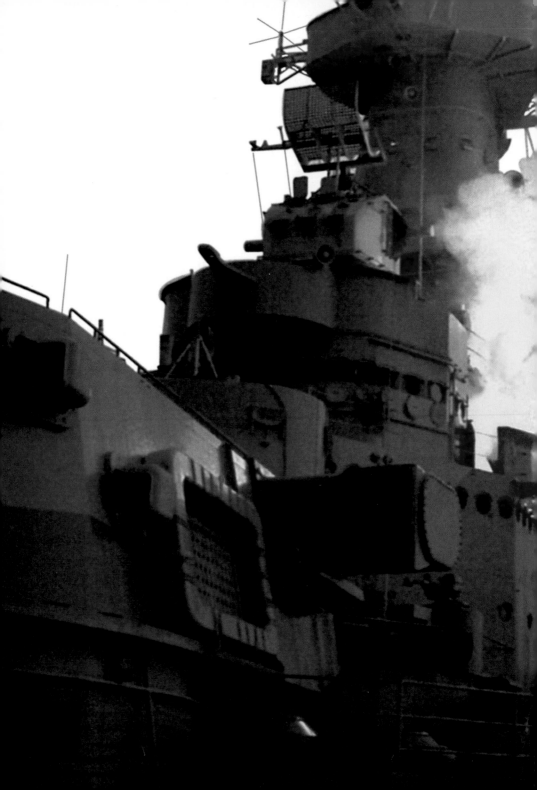

We created this fiery explosion onboard the U.S.S. North Carolina as part of a reenactment of the sinking of the *Bismarck*.

Extension cords are nothing more
than conductors and insulators.

Some Common Electrical Symbols

 Single Cell Battery

 Light Bulb

Switch

○ Terminal

 Shunt
(an intentional
short circuit.)

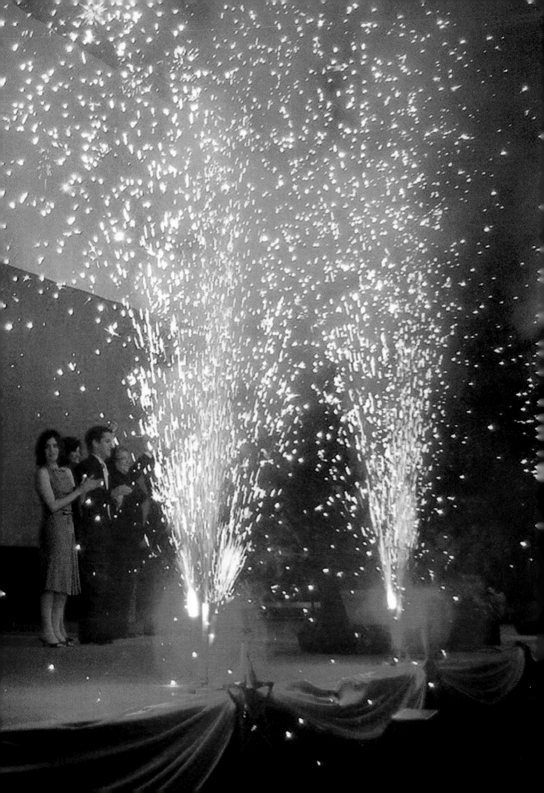

Electric Circuits

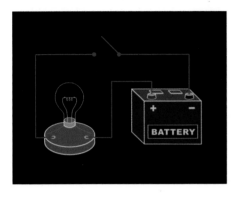

An electric circuit is a complete path that an electric current can follow. If there is a gap in the circuit, as there is here when this switch is open, current cannot flow.

When the switch is closed, the circuit is completed, and electricity flows through the circuit. This would cause a light bulb to light, a motor to turn, or, in my case, a pyrotechnic device to be fired.

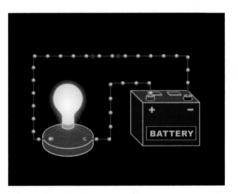

Serial & Parallel Circuits

A serial circuit is one in which all of the parts are connected in one big circle. The parts can consist of batteries, switches, lights, pyrotechnic devices or any other components, but an opening in any part of the circuit deactivates the entire circuit. This is an "all or nothing" circuit.

+ −

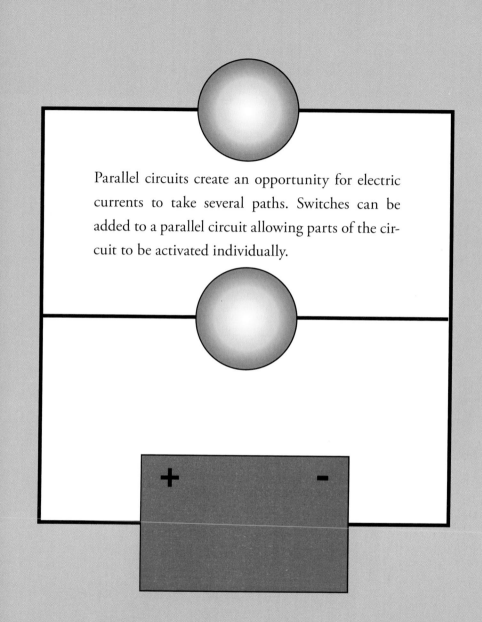

Parallel circuits create an opportunity for electric currents to take several paths. Switches can be added to a parallel circuit allowing parts of the circuit to be activated individually.

Serial and parallel circuits can be combined in the same project. For instance, you might want to have your components in parallel, but your safety switches in series.

Firing Box

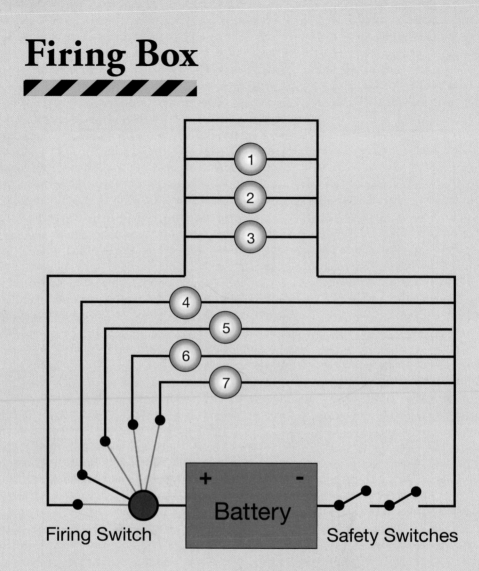

A firing box allows us to easily create both serial and parallel circuits, directing electricity to one or more components at a time. Serial safety switches ensure that devices are not fired accidently. All the leads from the pyrotechnic devices can also be routed to a Galvanometer that tests the circuit without firing any devices. The box also tests the battery and can accept an external power source.

Maegan Wolf has her finger on the main firing button.

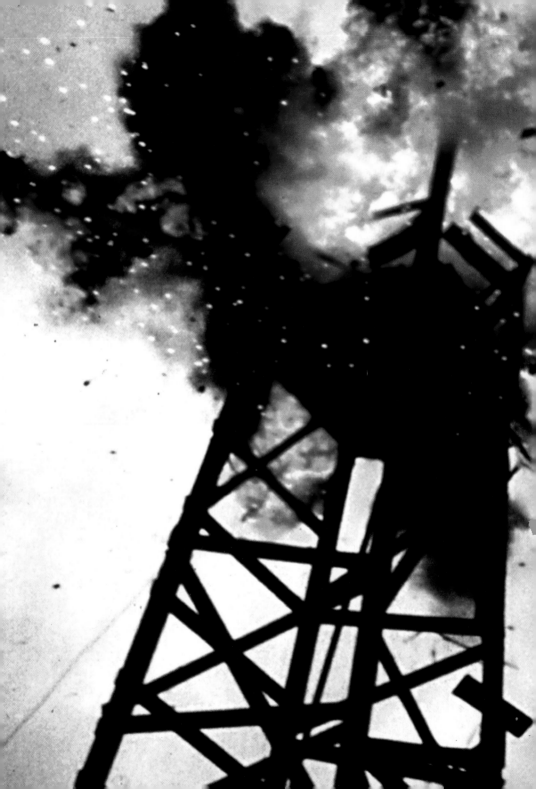

Scott Leva leaps from an exploding tower.

Atmospherics

One of the most common areas of movie special effects work is a field called *atmospherics*. As the name implies, atmospherics involves reproducing any effect that would normally be furnished by nature and the atmosphere. The atmosphere is the first five miles or so of space above the earth. Within this space, nature provides phenomena such as rain, snow, sleet, ice, smoke, haze, mist and wind. On a movie set, the special effects department must be able to create these conditions. While these effects don't usually stand out as "special" in the same way explosions do, they are very important so you have to be able to do them well.

Rain is made for movie sets by forcing water up a hose or pipe to a nozzle that breaks the water into droplets that fall on the set. You get the most powerful rainstorm effect by combining raindrops with mist and wind. Even though it's just "movie rain," you still need a raincoat.

In order to force the water up the hose, you have to put pressure on the water using a powerful pump. The more pressure you put on the water, the greater the force of the water is as it comes out of the nozzle.

Special nozzles are used to break the water into drops and mist. Good rain nozzles should not impede the flow of the water, and are available in various styles to create diverse drop sizes and patterns.

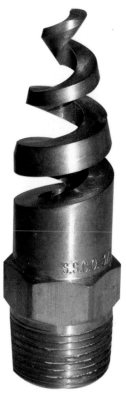

Here are "K," Mist and Spiral nozzles from Spraying Systems, Co. used to create rain.

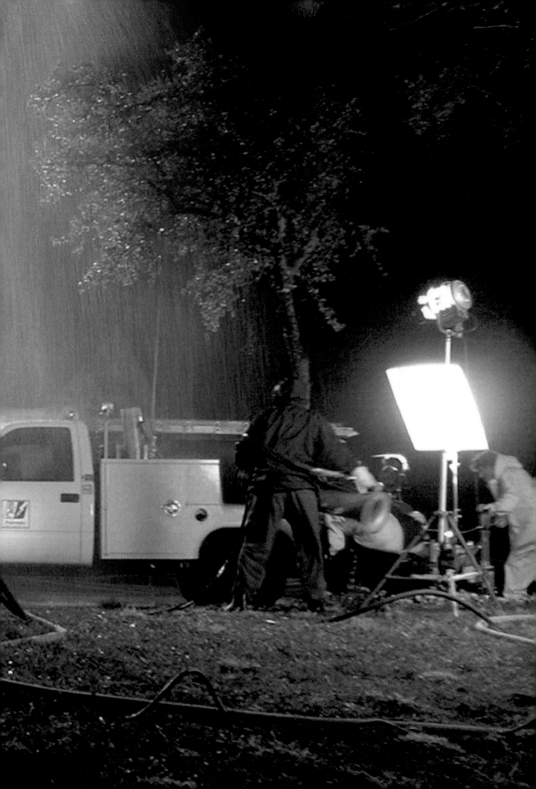

Snow is one of the most fun atmospheric effects, both in real life and on movie sets. There are many ways to make snow. If it's cold, you can make snow by spraying water vapor into the air, where it forms tiny crystals, just like real snow. To make real snow, the crystals (a solid) must be formed from water vapor (a gas) rather than from water itself (a liquid). In other words, it must go directly from a gas to a solid without becoming a liquid first. This process is called *deposition*.

When you cool water below 0° Celsius or 32° Fahrenheit, it turns from a liquid to a solid. This process is called *freezing*. If it's really cold out, it's very hard to make real snow because water may freeze in the hoses and pipes.

On days when it's warm or very cold, you make snow effect using foam, which is my favorite way to make snow. Foam is made of tiny bubbles.

We make a solution of SnowSyrup mixed with water.

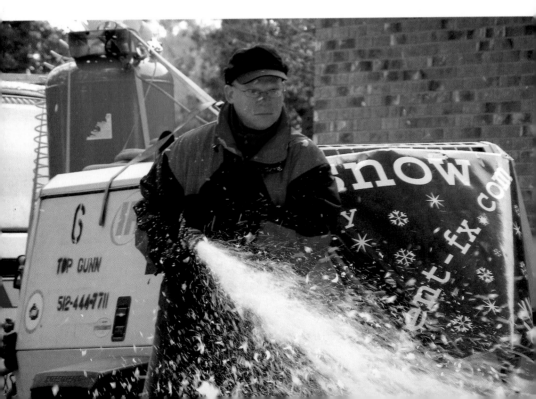

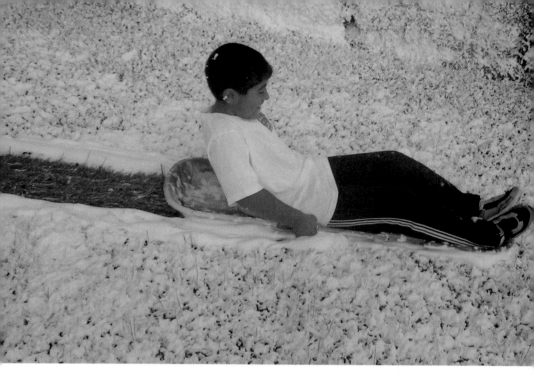

A *solution* is a liquid with something *dissolved* in it. Usually the liquid is water. We describe the concentration of the solution in terms of percentage. So, if I blend one gallon of SnowSyrup with 100 gallons of water, I would describe that as a 1 percent solution of SnowSyrup in water. Knowing the correct scientific way to describe what you are doing is important because it allows you to communicate with other scientists, and give or receive advice and tips. So, if a friend tells me to try a 1.5 percent solution, I know that means to blend 1.5 gallons of SnowSyrup in 100 gallons of water.

The SnowSyrup/water solution is placed into a tank, where I add air to pressurize it. Using valves to control the flow of the air and the solution, I direct air and the solution into a hose where they mix and form tiny bubbles called foam. The foam comes shooting out the nozzle of the hose, and I direct it up into the air so that it lands on the trees, houses, lawns, vehicles, props and even the people in our scene. You'd never know by looking that

12:01 p.m.

it's not real snow. But it's not cold, and doesn't melt. It lasts hours before the water evaporates and the bubbles burst.

Since movie work takes many hours and uses hot lights, real snow wouldn't last very long. Snow must usually be created artificially from materials that do not melt. A material called PolySorb, which can be found in diapers, is an excellent material from which to make small amounts of snow. You just blend it with lots and lots of water, and you have snow. If you add even more water, you end up with movie sleet.

Smoke is usually created by combustion, and is a product of the reaction that occurs when you burn something. Smoke consists of tiny particles of carbon floating in air, or floating in the gases created during the combustion process. While carbon isn't really dangerous, it wouldn't be good for you to fill your lungs with it, and the gases that are created from most fires contain poison gases—so when we want smoke on a movie set, we create it artificially, rather than by actually burning things.

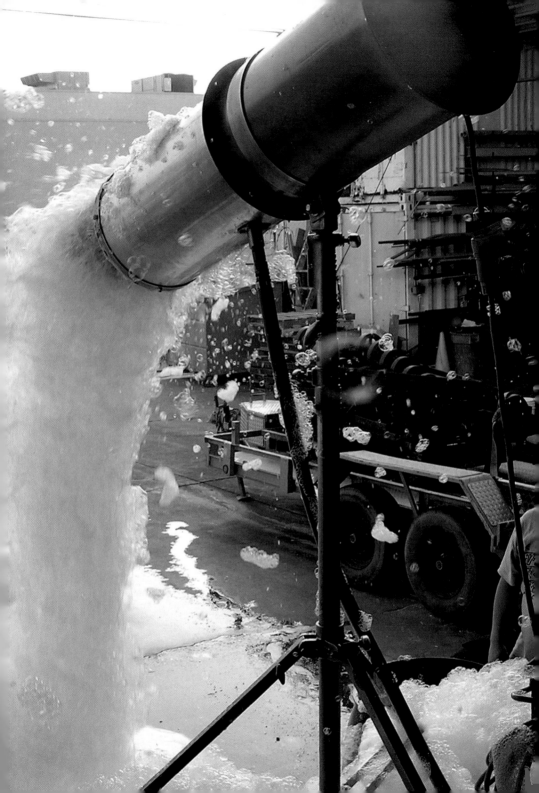

Steve Wolf creates a snow effect while...

Robert Stewart creates a steam effect.

Vance Holmes films burgers on the grill, while smoke fluid in the burgers enhances the visual effect of the grilling process.

Movie smoke usually is made by adding heat to a liquid to create a visible gas. There are many different machines available for making smoke, but most of them work on the same principal, using a heater and a pump.

When the concentration of the heated liquid (the smoke) is very high, the smoke is thick. As the chemicals we put into the air spread out, the smoke gets thinner and easier to see through. The chemicals we put into smoke machines must be safe for everyone on the set to breath. We have to be especially careful when using smoke machines

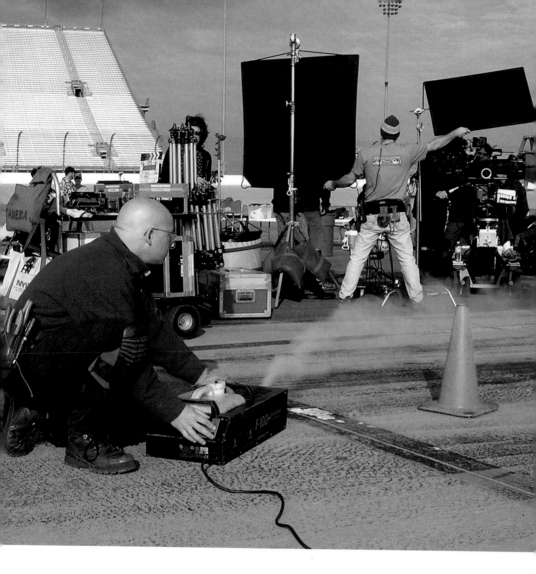

around people who have respiratory conditions such as asthma, and make sure the fake smoke does not irritate them. The only way to know if the chemicals being used are safe to breath is to read the labels. If you want more information about a substance than is printed on its label, you can get a document about the contents by asking the seller or the manufacturer for a Material Safety Data Sheet, also called an MSDS.

SAFETY CHECK

Material Safety Data Sheet

An MSDS contains information about a product that is not on the label. It may give you the chemical formula for a product, a more complete list of the ingredients, and facts about the reactivity of the product with other items that might produce dangerous reactions and products. It tells you how to safely store the product, how to clean it up if it spills, if the substance is harmful to people, plants or animals, if its flammable, and if so, how to extinguish it when it catches fire. It tells you if the product is safe to get on your skin or in your eyes, and how to clean it off of you. It tells you what to do if you accidentally swallow the product. You can learn a lot about products from their Material Safety Data Sheets. They are free, and stores and manufacturers must give you the sheets if you ask for them. I recommend getting some of them and learning how to read them, and making your own MSDS library of the products you use.

See Appendix on Page 174 for more information.

Haze

Haze consists of tiny particles of liquids or solids *suspended* in air. Haze has the effect of *diffusing*, or spreading out, light. Haze softens lighting to create a gentle or romantic atmosphere for a scene. Haze is created in the same way that movie smoke is created, but using different chemicals. Smoke usually has a source, such as a burning building or a smoldering pile of rubble, but haze appears to be evenly spread over an entire scene.

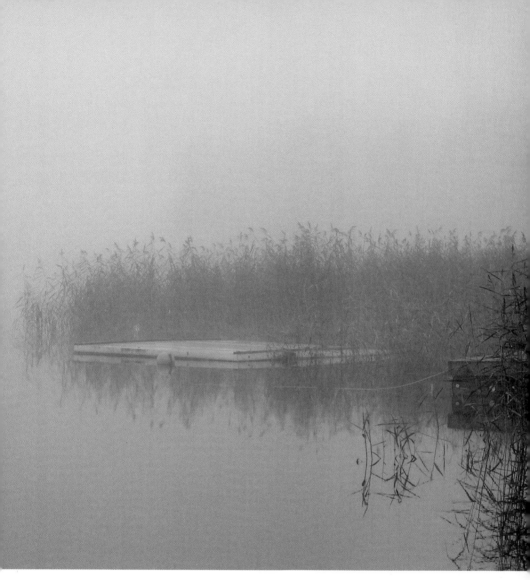

Mist

Mist is similar to smoke and haze, but is generally thought of as being a layer of visible atmosphere above something, as in "mist on the water" or mist in the valley above the trees. In order that mist not rise, it is usually cooled, so that it remains more dense than the air around it and remains low to the ground.

The right combination of lighting and haze turns an ordinary street into a mystical and serene setting. The choice of music could also make this scene scary or cozy.

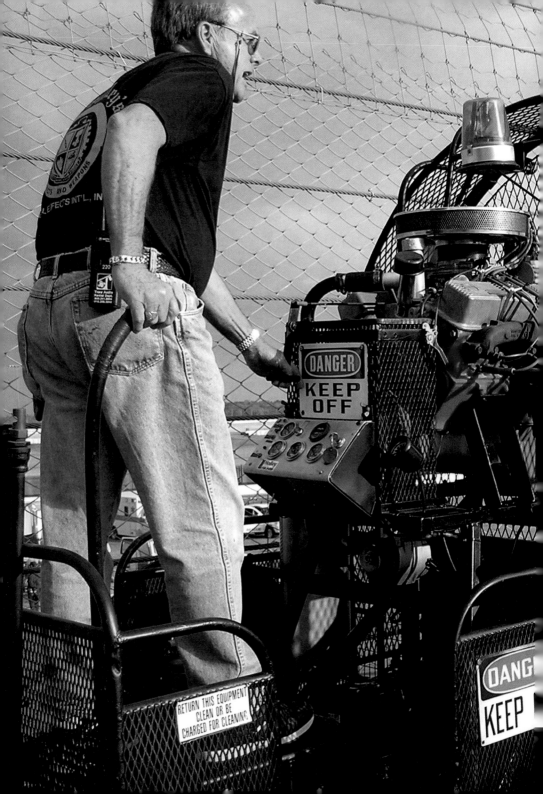

Wind is created on movie sets simply by moving air. Air can be moved by a fan, a blower, a jet, or by using an air moving device that runs on a Venturi Effect.

Powerful, gas-driven propellers are used to create large scale wind effects on movie sets. Here Bob Shelley operates one of his custom made wind machines. Don't stick your finger near the blades!

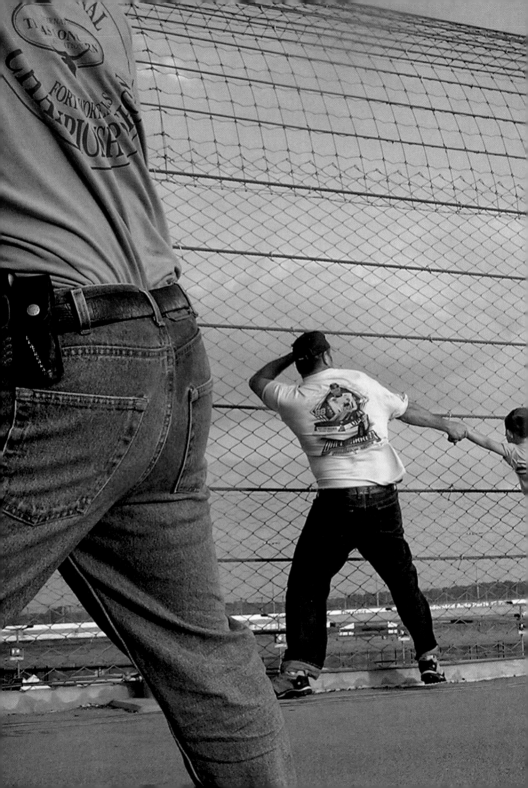

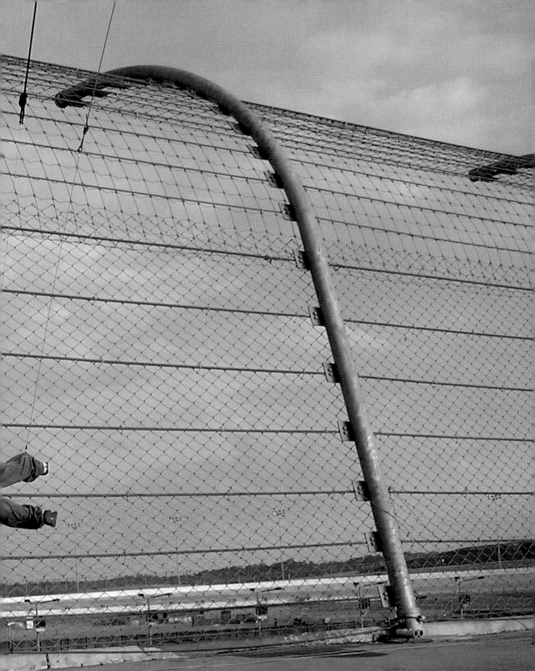

A combination of wind from our wind machine, and lift provided by some tiny cables, creates the illusion that this little boy is being blown into the air.

A Venturi Effect is created when you move a gas very quickly. Fast moving gases create low pressure zones and nearby air rushes into the low pressure zone, the result being that you can use a small amount of fast moving air to create a huge amount of slower moving air.

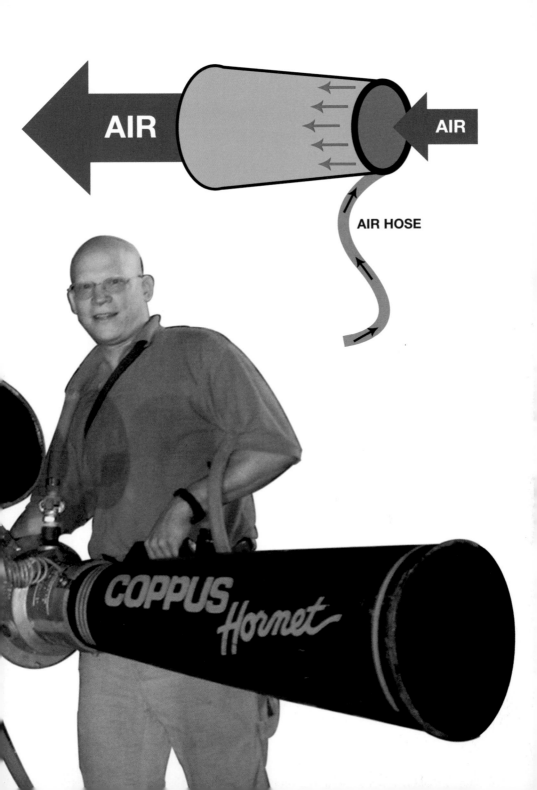

AIR

AIR

AIR HOSE

COPPUS Hornet

Real lightning involves atmospheric discharges of extremely high voltage electricity. We can use Van de Graaff generators to make lightning for movies. You can also create high voltage sparks using a Tesla coil. Working with electricity can be extremely dangerous—so we often simulate lightning using pyrotechnics or computer generated images.

A banana sized Tesla coil created these one inch tall sparks which can be enlarged to look like real lightning.

A large Tesla Coil in action.

Nikola Tesla is known as the original promoter of Alternating Current (AC). Thomas Edison was a fan of Direct Current (DC), which flows in one direction. Most of the world is now wired for AC current, which flows more efficiently.

Bringing It All Together

To film our movie explosion, we go through the following steps:

When we are ready to film the explosion, we must be certain the cameras are rolling. There are usually many cameras filming at the same time from different angles and with different lenses. It would be terrible to blow up a movie set only to find out that the cameras were not ready.

The first assistant director, also known as the AD, calls out, "Quiet on the set," so they can check in with all the people directly involved in the filming.

SAFETY CHECK

Safety on the Set

We have to protect the safety of everyone involved in making a film. Here are some of the ways we do this:

- •We grant access to the area only to people who are essential to the filming.
- •We keep everyone on the set at a safe distance. Distance is always part of a recipe for safety.
- •We maintain an orderly set, keeping talking and distractions to a minimum.
- •We warn everyone in the area that we will be creating an explosion, so that no-one is surprised when they hear a big bang. The warning phrase that precedes an explosion is usually "Fire in the hole!" If the blast is going to be really big, we also sound a horn several minutes in advance, so people who are far away can hear the warning. Sometimes we even have to notify the police and the FAA to keep cars and planes out of the area.

They check in with the camera department... "Cameras, set?" "Cameras, SET!" calls back the director of photography, known as the DP.

Then the AD checks with the stunt performers... "Stunts, set?" "Stunts, SET," calls back the Stunt Coordinator.

"FX, set?" "FX, SET, Sir," I call back. Two qualities that are essential in movie making are professionalism and courtesy. I call everyone "Sir" or "Ma'am." Remember, most people can be polite in the first hour of filming, but it's the mark of a pro to be just as polite and professional at the end of the fourteenth hour of filming. Fourteen hour days are not uncommon in movie making.

Then the AD lets everyone know we are really going to film... that this is not a rehearsal, so they call out "Pictures UP!" They check that

146

the cameras are rolling... "Roll A camera!" The camera operator then calls back to the AD to let him them know that the camera is rolling, by saying, "A camera, SPEED!"

We do the same thing for the B Camera... "Roll B camera!" calls the AD. "B camera, SPEED," calls back the second camera operator, and so on, until we know that all the cameras are rolling.

They remind everyone that a blast is coming by yelling, "Fire in the hole!"

Finally, the AD gives the call for the sequence to begin, with the words we've worked so long to hear... "Three, two, one, ACTION!"

As arranged in the choreography I've worked out with the stunt team, I arm the circuit that fires the explosives. At the moment the explosives are to fire, I press a button that touches two pieces of copper together, creating an electric circuit.

The circuit carries electrons from the negative terminal of the battery down through the copper wires to the explosive chemicals, or reactants. As the electrons pass through the narrowest part of the wire, where resistance to the flow of electrical current is highest, and where the wire touches the reactants, they bump against each other causing friction.

The friction creates heat.

Eddie Surkin attaches wires to an actor for a "blue screen" flying effect.

The heat triggers a chemical reaction.

The chemical reaction allows the molecules of the reactants to recombine, creating new substances, some of which are gases. The change from reactants to products is an essential part of the explosion. A great deal of energy is released.

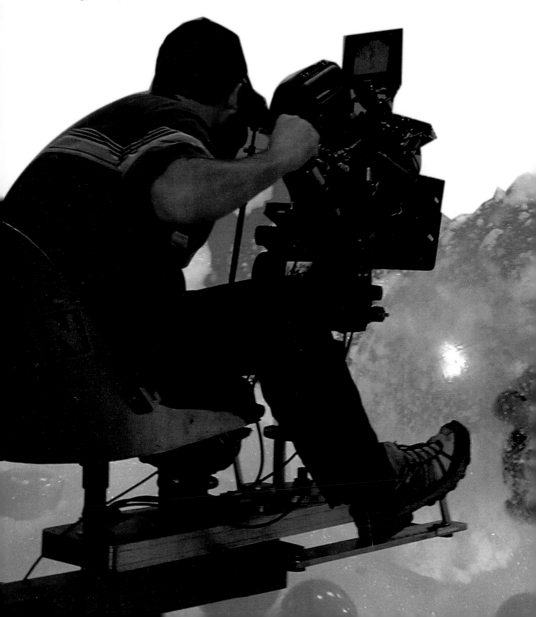

The gases created in the reaction expand, exerting pressure against every-thing around them. When that pressure finds the easiest direction it can travel, it moves out with terrific speed and force. The cloud of expanding gas slams into whatever is close to it with such force that it throws those items into the air or shatters them to pieces. When all the pieces have fallen back to earth, the fireball has burned up and the smoke has cleared, the AD yells, "CUT!"

"Cut" is a command to the camera crew to stop the cameras. It does not mean that it's safe to go on set.

First, we want to check that the stunt people are safe. Things are very tense on the set until we get a "thumbs up" from the stunt performers.

The special effects crew still has to check a few things before we can declare the area "clear" or safe. First, we want to make sure all the explosive devices have fired... that there are no reactants lying around that didn't go off.

I used my foam machine to create bubbles for this Flaming Lips video.

Then we make sure any fires that were started by the explosion are safely put out. Sometimes there are no fires, and sometimes there are fires that take hours to extinguish.

Remembering that fire requires four components, fuel, oxygen, heat and a chemical reaction, we can put out a fire by eliminating any one of those components. If we put out the fire by spraying water on in, we are removing the heat, the oxygen, and sometimes even the fuel.

When we've made sure that the set is safe, we call out "All clear" to let the rest of the crew know that it's now safe to come on set, and survey the wreckage. It is important not to move things on the set because the director may wish to "move in tighter" with the camera after they have gotten the wide "master shot," and film the after-effects of the explosion. We want to make sure things are in the same position they landed after they "blew up."

The movie crew can then go back to making the rest of the movie—the parts without all the stunts and special effects. So at that point, I can get ready to go home.

Teja McDaniel and I rehearsing a zipline stunt for NBC's *Three Wishes*.

Before I leave the set, I make sure all my tools are put back where they belong, that anything that got dirty has been cleaned up, that I thank all the people with whom I worked, and that I thanked and praised my crew for their terrific work. Making movies is a team effort, and I couldn't do it without an amazing team of professionals.

Stunt woman Kristin Philp always wears her safety equipment, such as this life jacket. This year her life was saved by her helmet and safety gear when she was in a motorcycle accident that happened on her way to work.

Getting Work

F requently people ask me what it takes to "make it" in the movie business. Professionalism. I recommend creating a list for yourself of what it means to be professional. I've found you can do it all with the letter "P."

Start with words like:

- Polite
- Prompt
- Punctual
- Persistent
- Prepared

- Physically fit
- Psychologically fit
- Pleasant
- Profitable
- Promise keeper

See how many "P" traits you can come up with that will help you in your career.

As you can see, the science and safety aspects of movie work are fairly straight forward. You can learn them in school or on your own. But the personality traits for succeeding are qualities you must develop on your own. If there are people you know and admire, think about the traits that make you look up to them, and then behave as they do. Building good character is just as important as building your knowledge. What you know is important, but who you are is more important.

I hope you've enjoyed taking a glimpse into the science of stunts and special effects, and that you're inspired to continue to learn more science, and to develop creative ways to use what you've learned.

Remember: you can accomplish anything you set out to do if you are willing to put in the effort. And it helps a great deal if you are working on a project that excites, inspires and helps others, so they will want to help you realize your dreams.

Science is simply a tool for understanding the world, and being able to create things you want or need. There is nothing really complicated about it, and once you get into it you'll see that everything in the world is connected. As you develop your knowledge of math and science, of engineering and technology, you'll find that creating things is easy. The important challenge is not whether or not you can create something, but coming up with things that are worth the effort of creating.

Thank you for spending this time with me, and I hope to hear about some of the ideas you're working on.

You can always reach me through the Science in the Movies website, at

www.scienceinthemovies.com

Be smart, be safe, and have fun.

Steve Wolf

Our team built this vest to break the record for explosives fired on a person for MTV's *Call to Greatness*.

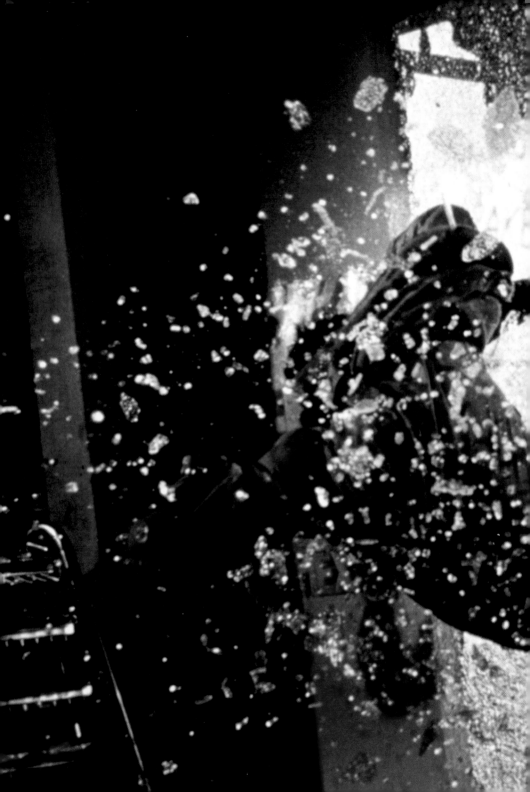

Stunt performer Scott Leva is thrown through a window. The window is made from a special glass, called "tempered glass" which shatters into tiny cubes, rather than large sheets, to keep him from becoming badly hurt.

Car windows are made from the same kind of glass.

Important Science Concepts

Acceleration

A change in velocity (speed) of an object.

Action/Reaction

For every action, there is an equal and opposite reaction. Newton's third law of motion.

Air Resistance

The friction an object encounters when it moves through the air.

Angular Momentum

The vector product of the position vector (from a reference point) and the linear momentum of a particle.

Archimedes' Principle

A body immersed in a fluid is held up by a force equal to the weight of the displaced fluid.

Bernoulli's Principle

As the speed of a moving fluid increases, the pressure within the fluid decreases.

Boyle's Law

Pressure and volume of a gas are inversely proportional to one another. PV=k (k is a constant).

Buoyancy

Upward force exerted by a fluid on any body immersed in that fluid.

Capacitance

The ability of an object to store an electrical charge.

Centrifugal Force

The apparent force, equal and opposite to the centripetal force, drawing a rotating body away from the center of rotation, caused by the inertia of the body.

Charge

Property of matter that gives rise to all electrical phenomena. (Basic unit: proton+ and electron-.)

Chemical Energy

Energy in a substance released by a chemical reaction.

Chemical Reaction

Process by which one or more substances may be transformed into one or more new substances.

Combustion

A chemical reaction of a carbon compound with oxygen that produces a gas and H_2O (and usually heat and/or light); burning.

Conductivity

The ability of an object to conduct heat, electricity, or sound.

Conservation of Momentum

A principle that states the total linear momentum of a system remains constant, regardless of changes within the system.

Coulomb's Law

Law in physics stating that the electrostatic force between two charged bodies is proportional to the product of the amount of charge on the bodies divided by the square of the distance between them.

Dalton's Gas Law

In a container containing a mixture of gas, the total pressure is equal to the combined pressure of its contents.

Density

The ratio of the mass of an object or substance to its volume.

Detonation

A chemical reaction propagated by a "faster-than-sound" shock wave through a rapidly burning fuel.

Distance of Drop

The change in height of a falling object.

Efficiency

A ratio of the work output to the work input.

Elasticity

An object's ability to resist stress (tension, compression, torsion) and return to its original state when the stress is removed.

Electrical Circuit

Path along which a current flows.

Electricity

Phenomena arising from the existence of charge.

Electromagnetism

Force of attraction or repulsion between certain metals, produced by an electric current.

Electron

The tiny negatively charged particles typically surrounding atoms.

Endothermic Chemical Reaction

Chemical reaction in which thermal energy (heat) is absorbed.

Energy

The ability or capacity to do work or produce change (heat, light, sound, electricity).

Energy Transformation

The principal that energy can be changed from one form to another.

Equilibrium

A state of balance. When a system is in equilibrium, there is no tendency to change.

Exothermic Chemical Reaction

Chemical reaction in which thermal energy (heat) is released.

Expansion of Gases

An increase in volume of a gas. It can be caused by an increase in temperature, a decrease in pressure, or the absence of confinement.

Explosives

Rapidly burning fuels whose chemical reactions give off tremendous energy when ignited.

Fire

A chemical change that releases heat and light and is accompanied by flame.

Fission

The splitting of the nucleus of an atom into nuclei of lighter atoms, accompanied by the release of energy.

Forces

A measure of the acceleration, or change in motion, imposed on a body by something else. The rate of change of momentum exerted on an object.

Friction

A resisting of movement between two objects.

Fusion

A nuclear reaction in which nuclei combine to form more massive nuclei with the simultaneous release of energy.

Galvanometer

An instrument for indicating or measuring low power electric circuits.

Gels

A semi-solid state of matter that generally holds its own shape, but due more to viscosity than crystallization.

Gravitational Acceleration

The acceleration that acts on all objects that fall within the earth's gravitational field. As an object falls, gravity pulls it toward the earth at an acceleration of 9.81 meters per second per second.

Gravity

Force of attraction between any two bodies.

Heat

Energy associated with differences in temperature between a system and its surroundings.

Heat Capacity

The amount of heat needed to change the temperature of a unit mass 1° C.

Inertia

The resistance of an object to any change. This applies to objects at rest as they are set in motion. It's the flip-side of momentum.

Insulation

Any material used to prevent the conduction of heat or electricity (fiberglass, fur, stone.)

Kinetic Energy

The energy an object has because it is in motion. $KE = 1/2\ mv^2$.

Law of Conservation of Energy

One of the most fundamental laws in nature stating that the total energy in a system remains unchanged during physical processes.

Law of Conservation of Mass

One of the most fundamental laws in nature stating that the total mass in a system remains unchanged during physical processes.

Levers

A simple machine consisting of a bar supported by some stationary point along its length (the fulcrum), and used to overcome resistance. The mechanical advantage is proportional to the length of the bar on either side of the fulcrum.

Light

Visible electromagnetic radiation: energy radiated in the form of a wave as a result of the motion of electric charges.

Magnetism

A force of attraction or repulsion between various substances, especially those made of iron and certain other metals; ultimately it is due to the motion of electric charges.

Mass

The amount of matter in an object disregarding volume and any forces acting on it.

Matter

Anything that has mass and occupies space.

Mechanical Advantage

The ratio of the output force produced by a machine to the applied input force.

Molecular Bonding

The means by which atoms in compounds are bonded to each other.

Molecule

A small physical unit of an element or compound, consisting of two or more like or different atoms.

Negative Acceleration

Negative change in velocity of object with respect to time.

Newton's Laws of Motion

1. An object at rest tends to stay at rest and an object in motion tends to

stay in motion with the same speed and direction unless acted upon by an unbalanced force. 2. The acceleration of an object with mass by an unbalanced force is directly proportional to the force and inversely proportional to the mass. 3. For every action, there is an equal and opposite reaction.

Optical Compression

The illusion that objects are closer to each other that they really are, created by positioning the objects on axis to a telephoto lens.

Optical Decompression

The illusion that objects are more distant, created by the use of wide angle lenses.

Pendulum motion

A mass suspended from a fixed point to swing from an arc. Determined by momentum and force of gravity. $T=\pi l/g$ (t=period, time for one complete swing, l=length of pendulum, g=gravity).

Physical Structure of Matter

The arrangement of the molecules from which a substance is composed.

Plasma

A state of matter that is a gas heated until the atoms lose all their electrons, leaving a highly electrified collection of nuclei and free electrons.

Potential Energy

The capacity an object has for doing work because of its position (stone resting on edge of cliff, stretched spring).

Power

The rate at which a given amount of work can be accomplished.

Pressure

Ratio of force acting on a surface to the area of the surface.

Pulleys

A simple machine consisting of a wheel with a grooved rim through which a rope or string is placed to change the direction of the pull and aid in lifting a load.

Pyrotechnics

Special effects achieved by vivid chemical reactions that create light and sound.

Radiation

The transmission of energy through space or a material medium.

Ramp

An inclined plane connecting two levels.

Rate of Thermal Transfer

The speed with which energy can pass through a given material.

Reflection

The "bounced" return of a wave.

Refraction

The turning or bending of a light wave as it passes from one medium to another medium of different density.

Resistance

A force that tends to oppose motion. A measure of how difficult it is for current to flow through a circuit. Measured in ohms.

Screw

A cylinder with an inclined plane wrapped around it.

Simple Machine

Arrangement of moving and stationary parts designed to perform work. (Example: lever, pulley, inclined plane, screw, wheel and axle.)

Sound

Directional wave that travels through a medium (air, ground, water, etc.).

Specific Heat

Ratio of the heat capacity of a substance to the heat capacity of a reference substance, usually water.

Speed

Change in distance with respect to time. A scalar quantity, does not depend on direction.

States of Matter

Solids, liquids, gases, plasma, gels.

Temperature

The average speed of the molecules in a substance. We perceive this as warmth or coolness of an object.

Tensile Strength

The maximum tension a material can withstand without tearing. A material's resistance to a linear force tending to deform the material.

Tesla Coil

An electrical device that generates extremely high voltages, usually for the purpose of creating dramatic electric arcs and lightning effects or for producing x-rays.

Thermodynamics

The study of the movement of energy.

Vacuum

Theoretical term for space without matter.

Vectors

Measure having both magnitude and direction. Force, momentum, and velocity are vectors.

Venturi Effect

Rapidly moving fluids create low pressure, causing nearby fluids to be drawn into the flow of material.

Appendix

You can get free MSDS downloads from our website, courtesy of Sargent-Welch:

ScienceInTheMovies.com

Guide To Material Safety Data Sheets

Material Safety Data Sheets (MSDS) are chemical information sheets. They give basic information about a product's content, potential hazards and physical characteristics as well as providing information necessary to allow the product to be used safely.

The Occupational Safety and Health Administration (OSHA) Hazard Communication Standard requires manufacturers or distributors of hazardous materials to assess the physical and health hazards of chemicals or products and provide that information in an MSDS. The MSDS must be forwarded to the purchaser with the initial shipment of each product free of charge. MSDS are not required to have a specific format but must contain the same basic information.

OSHA requires that MSDS be available for every chemical used in the workplace for employees to view during their work shifts.

The following example is based upon the OSHA recommended MSDS format and explains each section of the MSDS.

Identity

The name of the product as it is listed on the product label to allow you to easily match the appropriate MSDS to the product.

Manufacturer Information

This section provides the name and address of the manufac-

turer, a telephone number for product information and a telephone number to be used for emergency information.

A document date appears on each sheet to allow you to be sure you have the latest information.

Hazardous Ingredients & Identity Information:

This section contains:

• The chemical name of hazardous ingredients or

• If a mixture, the chemical names of the hazardous ingredients that make up at least 1% or the mixture (0.1% if the ingredient is a carcinogen (cancer causing) agent).

• CAS Number: a unique number assigned to chemicals or materials by the Chemical Abstracts Service

• Synonyms and/or chemical formulas

• Exposure Limits (if available) **Table 1** indicates the main limits.

Physical/Chemical Characteristics

This section outlines the physical properties of the material. This information may be used to determine conditions that may enhance exposure potential. See **Table 2**.

Table 1

Exposure Limits (Sources of safe limits for individual exposure)
PEL Occupational Safety and Health Administration (OSHA) Permissible Exposure Limit The regulated maximum concentration an employee may safely be exposed to in any 8 hour working day as measured by a time-weighted average. Ceiling limits (C) indicate an exposure level that may not be exceeded for any length of time during the working day. STEL or Short Term Exposure Limit indicates the average exposure level that may not be exceeded for a specified, short length of time (normally 15 minutes). A "Skin" notation indicates that the chemical may be absorbed through the skin.
TLV American Conference of Governmental Industrial Hygienists (ACGIH) Threshold Limit Values These values are not legal limits but are industry standard. TLVs are more current than regulatory limits. They are one source of industry standards used in creation of new regulations.
REL National Institute for Occupational Safety and Health (NIOSH) Recommended Exposure Limits This is a government funded, non-regulatory source of current exposure limit recommendations. They are one source of industry standards used in creation of new regulations.
Corporate Exposure Limit A recommended exposure limit based upon information gathered by the manufacturer or distributor.

176

Table 2

Boiling Point (BP)	Temperature at which liquid changes to vapor state.
Vapor pressure (mm Hg)	As a rule of thumb, higher vapor pressure materials evaporate more quickly.
Vapor density (Air = 1)	The weight of a gas or vapor compared to weight of an equal volume of air. Density greater than 1 indicates it is heavier than air. Vapors heavier than air can flow along or hover just above ground, where they may pose a fire or explosion hazard.
Solubility in Water	The percentage of material that will dissolve in water.
Appearance and Odor/ Odor Threshold	What the product should look like and/ or smell like. Often an odor threshold is included indicating the smallest amount of the material that can be detected by the human nose.
Specific Gravity ($H_2O = 1$)	The weight of a volume of liquid or solid compared to the weight of an equal volume of water. Materials with a specific gravity of greater than 1 will sink in water; less than 1 will float.
Melting Point	Temperature at which a solid begins to change to liquid state.
Evaporation Rate (Butyl Acetate =1)	The rate at which a material evaporates when compared to a known material's evaporation rate.
Other physical information will be given as appropriate.	

Fire and Explosion Hazard Data

This section includes information concerning the flammability of the material and information for fighting fires involving the product.

LEL - Lower Explosive Limit or LFL – Lower Flammability Limit (Terms are synonymous.)	The minimum concentration (percent by volume) of flammable vapor in air that will allow ignition. A product's flammable range is between the LEL and the UEL.
UEL - Upper Explosive Limit UFL – Upper Flammability Limit (Terms are synonymous.)	The maximum concentration of flammable vapor (percent by volume) in air above which ignition cannot occur. (The mixture above the UEL becomes "too rich" to support combustion.)
Flash Point	The lowest temperature at which a liquid gives off enough vapor to ignite when a source of ignition is present.
Auto ignition Temperature	The lowest temperature at which a flammable gas-air mixture will ignite spontaneously.
Extinguishing Media	The appropriate fire extinguishing agent(s) for the material.
Fire-fighting Procedures	Appropriate equipment and methods to be used in limiting hazards encountered in fire situations.
Fire or Explosion Hazards	Unusual conditions that may cause or lead to fire or explosions.

Reactivity Data

This section includes information regarding the stability of the material and special storage or use recommendations.

Stability	"Unstable" indicates that a chemical may react violently, decompose spontaneously under normal temperatures, pressures, or mechanical shocks, or rapid decomposition may produce heat, cause fire or explosion.
Incompatibility	Indicates chemicals or chemical families that may react violently or unpredictably in contact with the product. Incompatible chemicals should be separated during storage.
Hazardous Decomposition or By-Products	Hazardous substances that may be created when the chemical decomposes or burns.
Hazardous Polymerization	Indicates if the product is prone to rapid polymerization causing potential for explosion.

Health Hazard Data

This section indicates the medical signs and symptoms that may be encountered with overexposure to this product or its components. Health hazard information may also distinguish the effects of acute (short-term) and chronic (long-term) exposure.

Routes of Entry	• Inhalation: through the respiratory tract. • Ingestion: through the gastrointestinal tract (i.e., by eating contaminated foods or by touching the mouth with contaminated fingers). • Absorption: transference through the skin. • Injection: direct contact with the bloodstream (i.e., through needle stick or glass cut).
Health Hazards	Identification of target organs or systems that may be adversely affected by overexposure.
Carcinogenicity	Substances that are suspected or known to cause cancer in humans.
Signs and Symptoms of Exposure	Identification of the outward appearance or feel of overexposure.
Medical Conditions Generally Aggravated by Exposure	Medical conditions that may be aggravated by normal exposure or overexposure.
Emergency and First Aid Procedures	Recommended emergency and first aid procedures based on the toxicity of the product, degree of exposure and route of contact.

Precautions for Safe Handling and Use

This section provides general information for safe handling and use. Local regulations must also be taken into consideration in dealing with spills and waste disposal.

Spill or Release Data	Materials and methods to use in a small, moderate or large spill situation.
Waste Disposal Method	Indicates if the product must be disposed of as a hazardous waste. Utilize university guidelines in determining disposal methods and procedures.
Precautions to Be Taken in Handling and Storage	This section may contain incompatibility information as well as special precautions for use or storage.
Other Precautions	Other hazards or precautions not elsewhere listed.

Control Measures

This section includes general information about appropriate personal protective equipment for handling this material. Many times, this section is written for large scale use of the material. Consider the amount and use of a material when choosing personal protective equipment.

Respiratory Protection	Indicates the type of respirator recommended. Some respirators supply air while others filter room air. Use of a respirator requires a medical exam, training and fit testing.
Protective Gloves	Use compatible glove materials based upon the chemical used.
Eye Protection	Safety glasses or Splash goggles must be ANSI approved for the intended use. Look for the ANSI imprint on the lens. Standard prescription glasses are not suitable safety glasses.
Protective Clothing	Recommended clothing may not be feasible for lab use.
Ventilation	Recommendations for general room ventilation and/or point source local exhaust ventilation.
Work/Hygienic Practices	Special recommendations for use.

Fall Table

Look up the height of the fall in the first column. You'll see the time it takes to hit, the impact speed and the impact force for people or objects of various weights.

HEIGHT	TIME	IMPACT SPEED	IMPACT (FOOT POUNDS) FOR INDICATED WEIGHT (LBS)								
Feet	Seconds	MPH	1	50	75	100	125	150	175	200	250
1	.25	5.47	1	50	75	100	125	150	175	200	250
5	.56	12.23	5	250	375	500	625	750	875	1000	1250
10	.79	17.30	10	500	750	1000	1250	1500	1750	2000	2500
16	1.00	21.88	16	800	1200	1600	2000	2400	2800	3200	4000
20	1.12	24.46	20	1000	1500	2000	2500	3000	3500	4000	5000
30	1.37	29.96	30	1500	2250	3000	3750	4500	5250	6000	7500
40	1.58	34.59	40	2000	3000	4000	5000	6000	7000	8000	10000
50	1.76	38.67	50	2500	3750	5000	6250	7500	8750	10000	12500
60	1.93	42.37	60	3000	4500	6000	7500	9000	10500	12000	15000
64.5	2.00	43.93	64.5	3225	4838	6450	8068	9675	11288	12900	16125
70	2.09	45.76	70	3500	5250	7000	8750	10500	12250	14000	17500
100	2.49	54.69	100	5000	7500	10000	12500	15000	17500	20000	25000
150	3.05	66.99	150	7500	11250	15000	18750	22500	26250	30000	37500
200	3.53	77.35	200	10000	15000	20000	25000	30000	35000	40000	50000

Periodic Table of the Elements

GROUP

PERIOD

Solids	Liquids	Gases	Artificially Prepared

Atomic Number — **26**
Symbol — **F**
Name — **I** 55

IA										
1 **H** Hydrogen 1.00794	IIA									
3 **Li** Lithium 6.911	**4** **Be** Berylium 9.01218									
11 **Na** Sodium 22.98977	**12** **Mg** Magnesium 24.3050	IIIA	IVA	VA	VIA	VIIA				VII
19 **K** Potassium 39.0983	**20** **Ca** Calcium 40.078	**21** **Sc** Scandium 44.95591	**22** **Ti** Titanium 47.877	**23** **V** Vanadium 50.9415	**24** **Cr** Chromium 51.9951	**25** **Mn** Manganese 54.93805	**26** **Fe** Iron 55.845	**27** **C** Co 58.9		
37 **Rb** Rubidium 85.4678	**38** **Sr** Strontium 87.62	**39** **Y** Yttrium 88.90585	**40** **Zr** Zirconium 91.224	**41** **Nb** Niobium 92.90638	**42** **Mo** Molybdenum 95.94	**43** **Tc** Technetium (98)	**44** **Ru** Ruthenium 101.07	**45** **R** Rho 102.9		
55 **Cs** Cesium 132.90545	**56** **Ba** Barium 137.327		**72** **Hf** Hafnium 178.49	**73** **Ta** Tantaium 180.9479	**74** **W** Tungsten 183.84	**75** **Re** Rhenium 189.207	**76** **Os** Osmium 190.23	**77** **I** Irid 192		
87 **Fr** Francium (223)	**88** **Ra** Radium (226)		**104** **Rf** Unnilquadium (261)	**105** **Db** Unnilpentium (262)	**106** **Sg** Unnnilhexium (263)	**107** **Bh** Unnilquadium (264)	**108** **Hs** Unnilpentium (265)	**109** **M** Unnnil (2		

57 **La** Lanthanum 13.9055	**58** **Ce** Carium 140.115	**59** **Pr** Praseodymium 140.90765	**60** **Nb** Neodymium 144.24	**61** **Pm** Promethium (145)	**62** **S** Sam 15(
89 **Ac** Actinium (227)	**90** **Th** Thorium 232.0381	**91** **Pa** Protactinium 231.03588	**92** **U** Uranium 238.0289	**93** **Np** Neptunium (237)	**94** **P** Plut (2

VIII

						2 **He** Helium 4.00260

IIIB	**IVB**	**VB**	**VIB**	**VIIB**	

tomic Weight

5 **B** Boron 10.811	**6** **C** Carbon 12.0107	**7** **N** Nitrogen 14.00674	**8** **O** Oxygen 15.9994	**9** **F** Fluorine 18.99840	**10** **Ne** Neon 20.1797

IB	**IIB**	**13** **Al** Aluminum 26.98154	**14** **Si** Silcon 28.0855	**15** **P** Phosphorus 30.97376	**16** **S** Sulfur 32.066	**17** **Cl** Chlorine 35.4527	**18** **Ar** Argon 39.948

29 **Cu** Copper 63.546	**30** **Zn** Zinc 65.39	**31** **Ga** Gallium 69.723	**32** **Ge** Germanium 72.61	**33** **As** Arsenic 74.92160	**34** **Se** Selenium 76.95	**35** **Br** Bromine 79.904	**36** **Kr** Krypton 83.80

47 **Ag** Silver 107.8682	**48** **Cd** Cadmium 112.411	**49** **In** Indium 114.818	**50** **Sn** Tin 118.710	**51** **Sb** Antimony 121.760	**52** **Te** Tellurium 127.60	**53** **I** Iodine 126.90447	**54** **Xe** Xenon 131.29

79 **Au** Iridium 192.96655	**80** **Hg** Mercury 200.59	**81** **Tl** Thallium 204.3833	**82** **Pd** Lead 207.2	**83** **Bi** Bismuth 208.98038	**84** **Po** Polonium (209)	**85** **At** Astatine (210)	**86** **Rn** Polonium (222)

111 **Uuu** Unnnilhexium (272)	**112** **Uub** Unnnilhexium

64 **Gd** Gadolinium 157.25	**65** **Tb** Terbium 158.92534	**66** **Dy** Dysprosium 162.50	**67** **Ho** Holmium 164.93032	**68** **Er** Erbium 167.26	**69** **Tm** Thulium 168.93	**70** **Yb** Ytterbium 173.04	**71** **Lu** Lutetium 174.957

96 **Cm** Curium (247)	**97** **Bk** Berkelium (247)	**98** **Cf** Californium (251)	**99** **Es** Einsteinium (252)	**100** **Fm** Fermium (257)	**101** **Md** Mendelevium (258)	**102** **No** Nobelium (259)	**103** **Lr** Lawrencium (260)

Index

Contacts & Resources

To schedule a live presentation by our science stunt team, visit

www.ScienceInTheMovies.com

We have Teacher Workbooks, Student Workbooks and Science Kits that accompany this book, and you can order more copies of this book at our website.

SecretScienceBehindMovieStuntsAndSpecialEffects.com

Many of the machines and products mentioned in this book are available on our website.

End Credits

Principle Photography
Steve Wolf

Graphic Design
Jenifer Bryan

Additional Photographs
Robert Stewart, Cheryl Duncan, Scott Leva

Model Rocket Image page 11
Courtesy of Estes-Cox Corporation

Illustration
John Boyles, Jenifer Bryan, Steve Wolf

Fall Table page 183
Apostolos Lerios

Periodic Table of the Elements
Furnished by

Sargent-Welch
VWR

I would also like to thank Holly Ahern of Sargent-Welch
for her tireless support of many science education projects
over the years.

Special thanks to Emily Simmons, Emily Brandt and Sarah
Chapman for organizing all the thoughts in this book

Additional Contributions
Clayton Sheffield, Jennifer Roberts, Lanette Miller